Are you up to it?

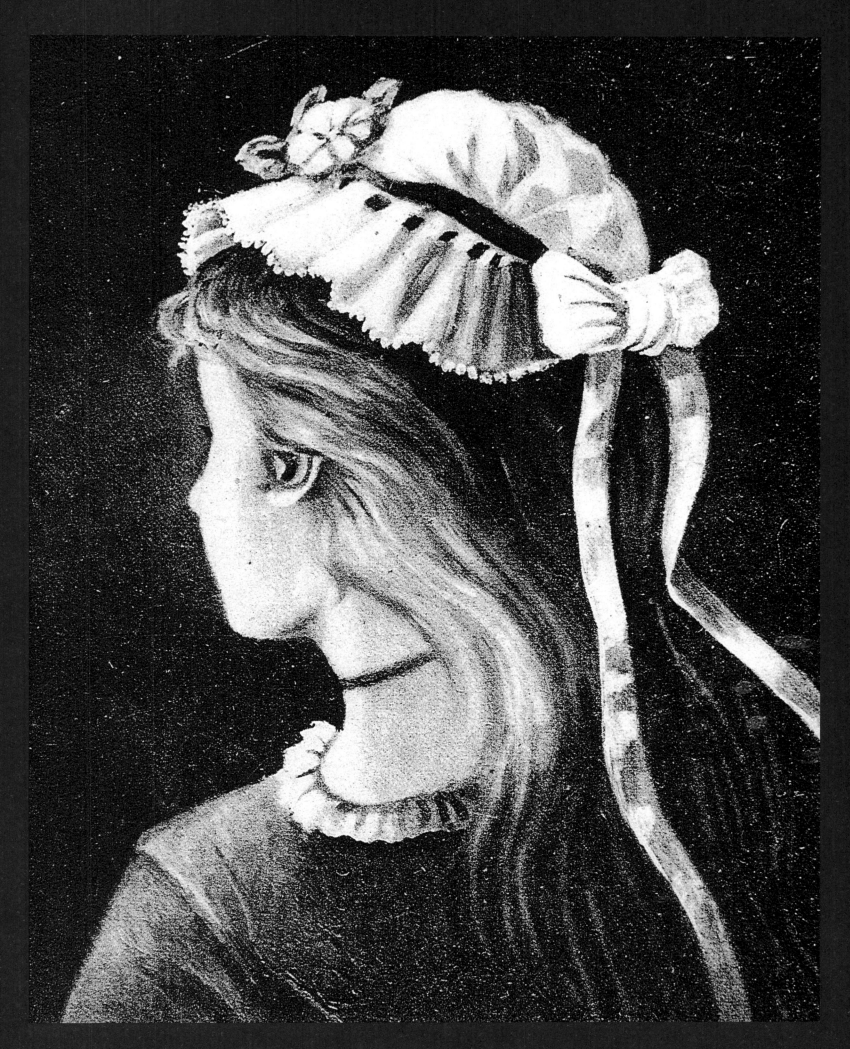

My wife and my mother-in-law

The Playful Eye

The Playful Eye

Over 100 Illusions of Visual Delight

Edited by
Julian Rothenstein & Mel Gooding

BARNES & NOBLE

NEW YORK

Acknowledgments
Thanks to Hiang Kee, Yuka Lowe, Peter Allen, Pierre Patau, Julie Onishi, Joanna Dodsworth, Tokyo Shoseki Co. Ltd,
Shigeki Oyama, Balraj Khanna, Joost Elffers, Marianne Ryan, Christabel Gurney, Eric Ayers, Andreas Landshoff, Anne
Clarke, Sam Adams

Illustration credits
Courtesy James Dalgety Collection x, 4, 5, 6, 7, 8, 10 *(top right),* 11, 28, 29, 41 *(top left, top right, bottom left),* 42, 46,
52, 56, 57, 58, 64, 68, 69, 70, 87. Courtesy Edward Hordern Collection iii, vii, 10 *(top left, bottom left and right),* 12, 16,
32, 48, 53, 54, 55, 84, 85, 86. Courtesy Shin-Ichi Inagaki from *Playing Pictures,* published by Tokyo Shoseki, Tokyo, 1998
17, 20 *(left, right),* 21, 23, 24, 43, 45. Courtesy Mary Evans Picture Library 9. Courtesy Balraj Khanna 18. Courtesy Tim
Rowett 19 *(right).* Courtesy Bodleian Library, University of Oxford: John Johnson Collection, puzzle-picture folder 30/31,
35, 62, 63, 65, 66, 67, 88. Courtesy German National Museum, Nürnberg 33. Courtesy Salvador Dali/Foundation Gala-
Salvador Dali/DACS, 1999 36. Courtesy The Paper Museum, Tokyo 43. Courtesy Jasia Beresiner 74-80. Courtesy Peter
Allen 92-99.

INTRODUCTION

'Appearances reach us through the eye, and the eye – whether we speak with the psychologist or the embryologist - is part of the brain and therefore hopelessly involved in mysterious cerebral operations.' Leo Steinberg

The eye seeks meaning. At every moment of intelligent apprehension the mind organises configurations of information out of the infinitude of visual facts that present themselves to the eye. We are programmed to make sense of the world, to construct coherence. So intimately connected is the mechanical faculty of seeing to the mental faculties of comprehension that when we understand something we exclaim, 'I see!', and when we want someone else to understand something we say, 'look at it this way'. This metaphorical identification goes deeper: those who understand things beyond the ordinary, or who have prophetic gifts, we call 'seers', and attribute to them 'visionary' powers. We speak of the eye as if it were itself the informing faculty, that which construes, or 'reads' the world; and there is indeed much serious work for this eye to do.

But the eye also likes to play, finding in the welter of visual impressions resemblances between quite different things: that is the beginning of poetry and of art. Metaphor, the essence of the artistic vision, is the recognition of a profound kind of coherence, it is a construction put upon the world, a making of vital connections. It discovers meanings that defy the rational understanding, but which satisfy a deep human need for things to be seen as belonging to a pattern, and for there to be signs which indicate hidden affinities, unsuspected relations and associations. The eye seeks these signs, the mind interprets them. The world is revealed as continuous, predictable and comprehensible, and yet full of unexpected affinities and surprising correspondences. There is an ancient belief that these signs may be hidden in things encountered every day, at any moment. Sometimes they are overt, sometimes cryptic. As we go through the world we continually discern these relations, play the game of seeing similarities between dissimilar things; we are inveterate metaphor-makers, makers of myths.

Art reflects and amplifies this propensity. Visual artists have always played tricks upon the mind. Indeed, all the various modes of representation are based upon optical illusion, and rely upon the readiness of the mind to read marks as signs and to recognise visual conventions. They are, of course, always intended to do more than provide a mere simulacrum of things seen and known in the world. Art has its purposes, and these have ranged from the magical to the religious to the philosophical, from the didactic to the ostentatious to the entertaining. Art uses metaphor, it encodes those signs that the eye seeks so avidly. And it can also conceal within a picture hidden meanings attached to cryptic signs. Much of this cryptic art is of an exalted kind: the religious painting of the Renaissance, for example, or the great Dutch still life painting of the seventeenth century or Victorian didactic painting. Such art does not usually rely, however, upon optical trickery so much as upon emblematic symbolism or visual allusion: the butterfly that refers to the transience of worldly life; the snake that reminds us of the Fall. The most famous exception is, perhaps, the anamorphic skull in Holbein's *The Ambassadors*.

Until the advent of Op Art in the late 1950s most of the art that played visual games and optical tricks, however, was of the humblest and most ephemeral kind, and much of it set out to do little more than amuse. It is from the genres of such popular imagery that this collection is drawn. Like most popular art it is characterised by simplicity, and by its vivid directness of address to its public. It succeeds by exploiting the universal enjoyment of visual discovery, of seeing something to be present of which we had not been aware before, of finding a resemblance or correspondence between things that we had not anticipated, or of simply being deceived by our senses. That having been said, it is nevertheless the case that many of the most common visual tricks and games have been used at one time or another for satirical effect, to disguise political messages, or to demonstrate psychological or philosophical ideas. It is true of all of them that they may in various ways encourage reflection on the vagaries of perception and on the mysteries of human consciousness. Optical illusions fascinated two of the greatest minds of the century: for Duchamp they provided method and material for art, and for Wittgenstein the provocation to philosophical investigation. There is food for thought in these pages. But above all there is visual delight, the pleasure of the eye in things witty, comic, spectacular and beautiful.

MEL GOODING

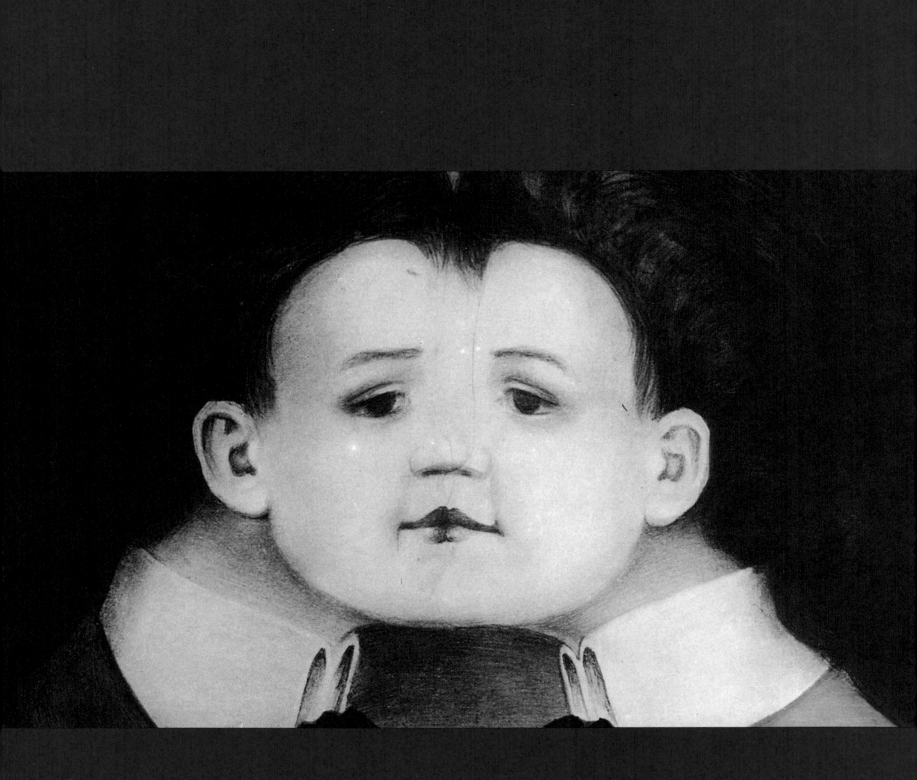

The Kiss and its Consequences

1

HIDDEN IMAGES

1

HIDDEN IMAGES

To hide one image within another is an old trick. It is a kind of encoding, in the sense that we use that term in relation to spying: the ostensible text or picture hides a secret message. Sometimes such hidden images are simply visual puzzles, designed to amuse and pass the time, and perhaps secure attention to the advertisement of a product; sometimes they are cryptically poetic (or, as we shall see, political). *Toll Gate No 2*, for example, is an advertisement for patent medicine which contains no fewer than 75 hidden outlines of people, animals, objects and letters. In a case of the poetic, Heine's song is mapped on to a complicated geography of a love requited but, for some reason, impossible to consummate; the salt sea that separates two coasts, filled with bitter tears, is an apt metaphor for the gulf between the lovers:

When I look into your eyes
Then flies away all pain,
But when your lips I kiss
I know the truth again.

When I lean upon your breast
I faint with heaven's lust,
But just declare your love
Then weep again I must.

There is here a double disguise, for the lovers are hidden in the map, and the poem in the words of the markings on the map.

There is a natural propensity to trace human and animal profiles and features in natural phenomena; to see a face in profile in the outline of a tree, to discern in the shape of a rock the figure of a bull. And we are infinitely suggestible in these matters:

Hamlet: Do you see yonder cloud that's almost in the shape of a camel?
Polonius: By the mass, and 'tis like a camel, indeed.
Hamlet: Methinks it is like a weasel.
Polonius: It is backed like a weasel.
Hamlet: Or like a whale?
Polonius: Very like a whale.

Discovering an unexpected likeness between things quite unconnected, or discerning a face or a figure in a phenomenon that has its own distinct identity, can be disconcerting, amusing, or even seem like a revelation. *Cherchez le tigre* is an example of a common puzzle; more original and witty is J.M. Flagg's projection of a pretty female face on to a map of the world. Archimboldo's famous device – creating a composite image (usually of a head, but sometimes of a landscape) out of particular ingredients (fruit, flowers, natural landscape features) – has been adapted by many artists for satirical or ironically sinister effect. An example of the latter were the turn-of-the-century postcard images of the devil, or of Mephistopheles, whose features composed of ecstatic women clearly signalled the association of female sexuality with terrible perdition. The *memento mori* skull has also provided a poignant motif that can be ingeniously exploited; death is prefigured in Pierrot's tryst and the lover's kiss.

Some of the most deeply poetic instances of hidden imagery are those in which we discover a ghostly presence in the living world. The shade of Napoleon, a substance-less image, visits his lonely grave on the remote island of his last exile. The most powerful commander in the world is reduced to a transparent nothing. All the great must share this fate, including the first President of the United States. *Vanitas*! A young man, looking out to sea from a rocky coast, thinking perhaps of Greece and of Byron's heroic death at Missolonghi, is visited by the invisible spirit of the great poet. In a beautiful visual elegy, Byron has become himself part of nature, 'rolled round in earth's diurnal course/With rocks, and stones, and trees'. In a more prosaic celebration, the young Queen Victoria, just acceded to the throne, is hailed as a lively presence in Windsor Great Park.

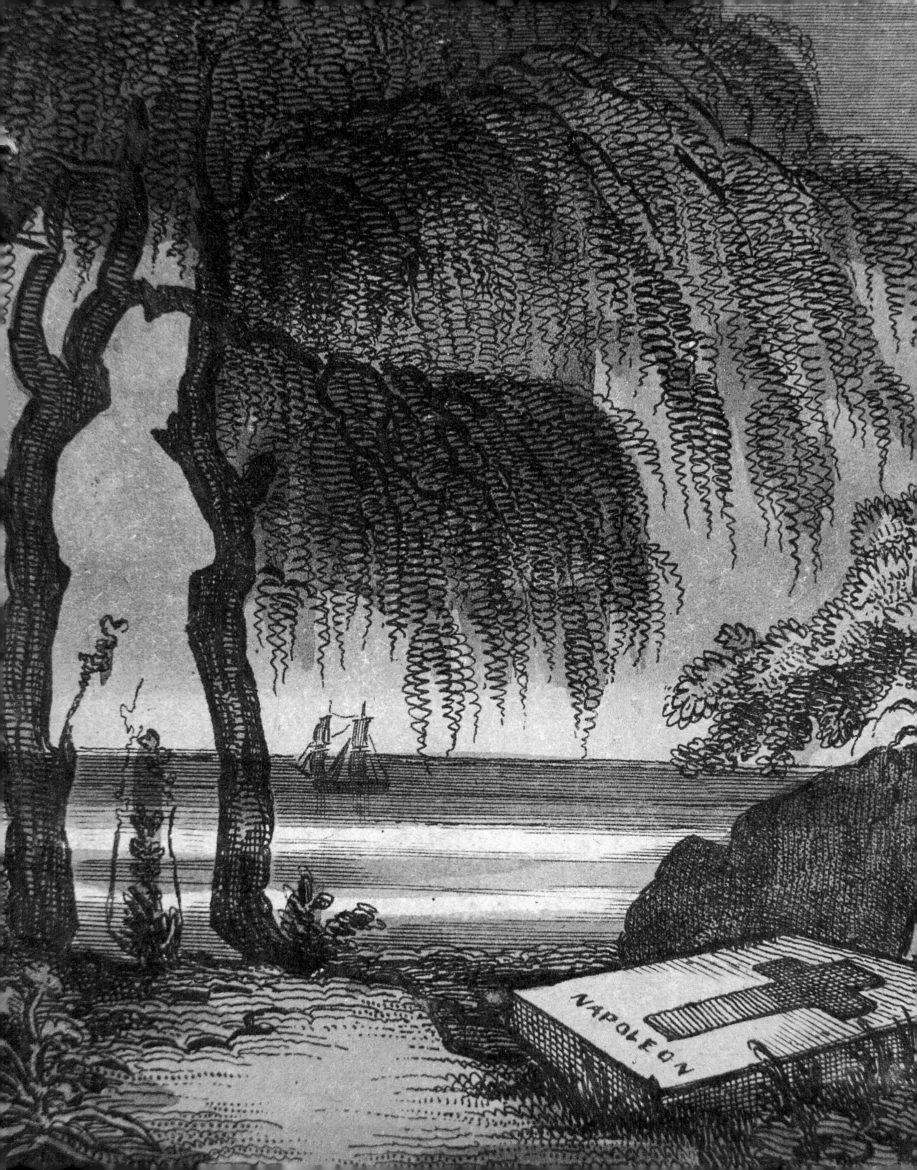

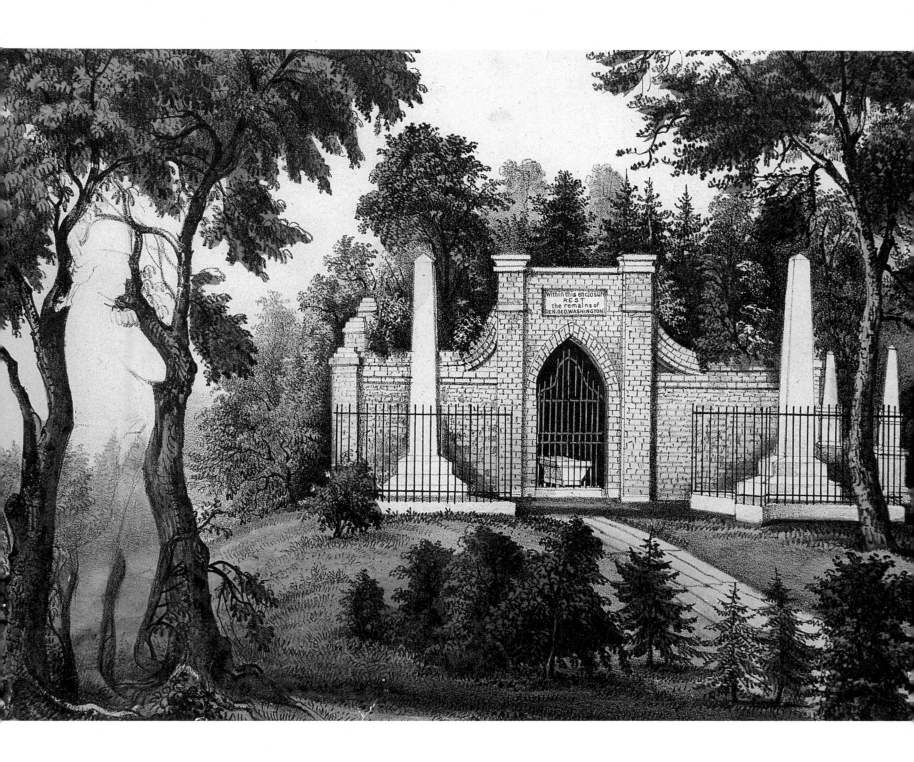

Left The shade of Napoleon *Above* Washington at his tomb

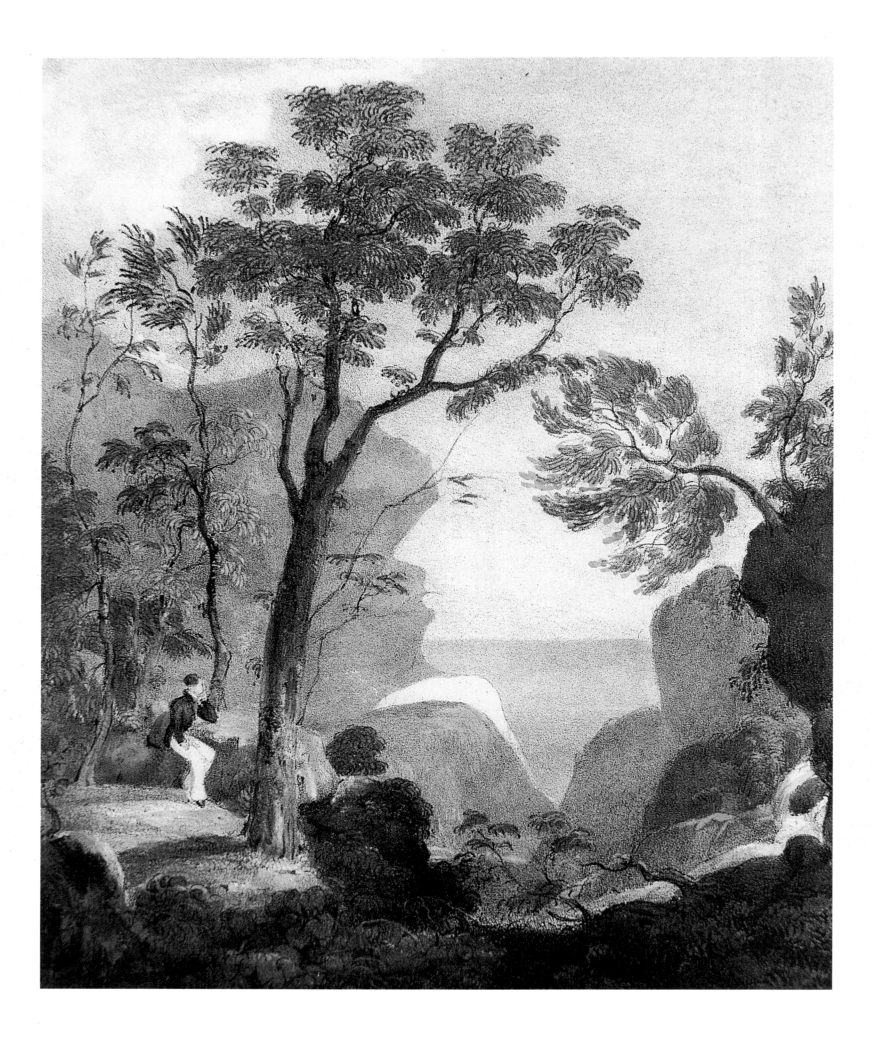

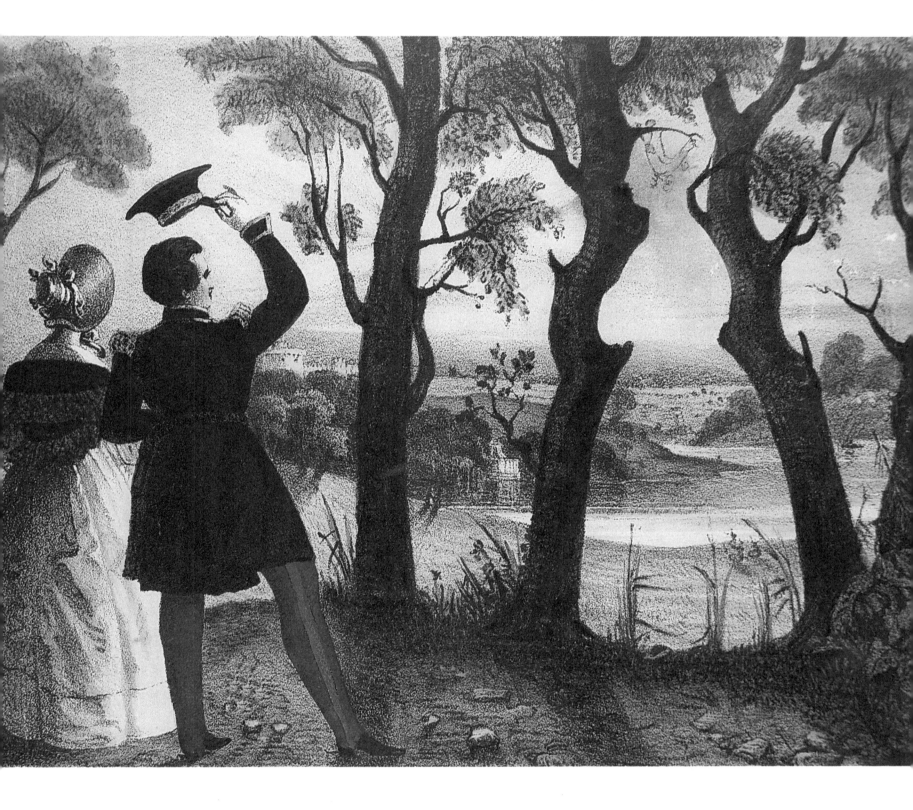

Left The Spirit of Byron *Above* Scene near Windsor

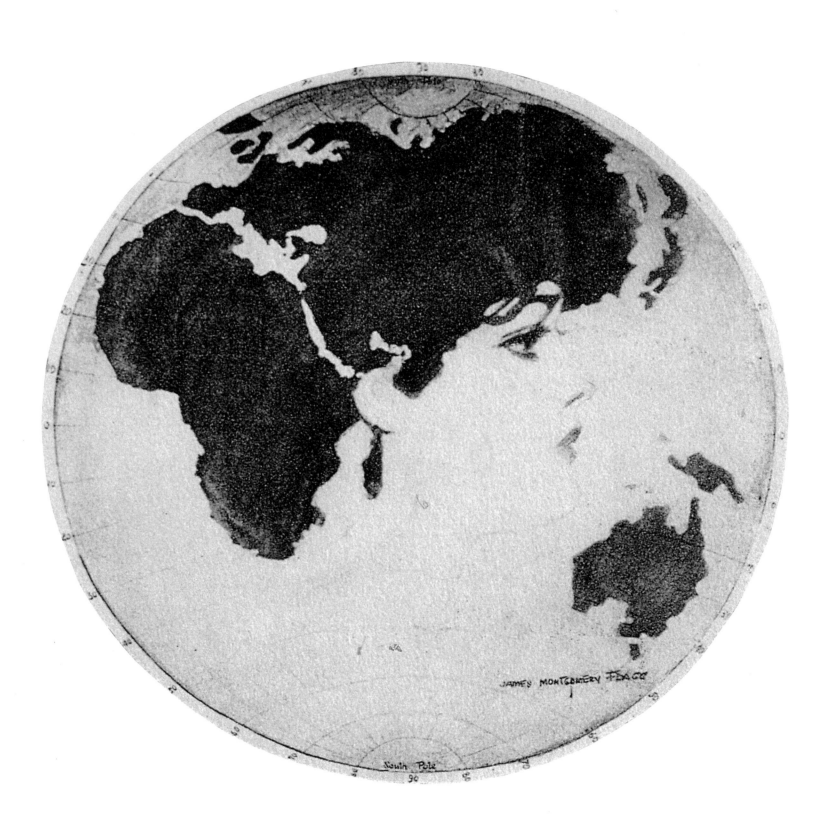

JAMES MONTGOMERY FLAGG

Above A map of the world *Right* Lady in a landscape

8

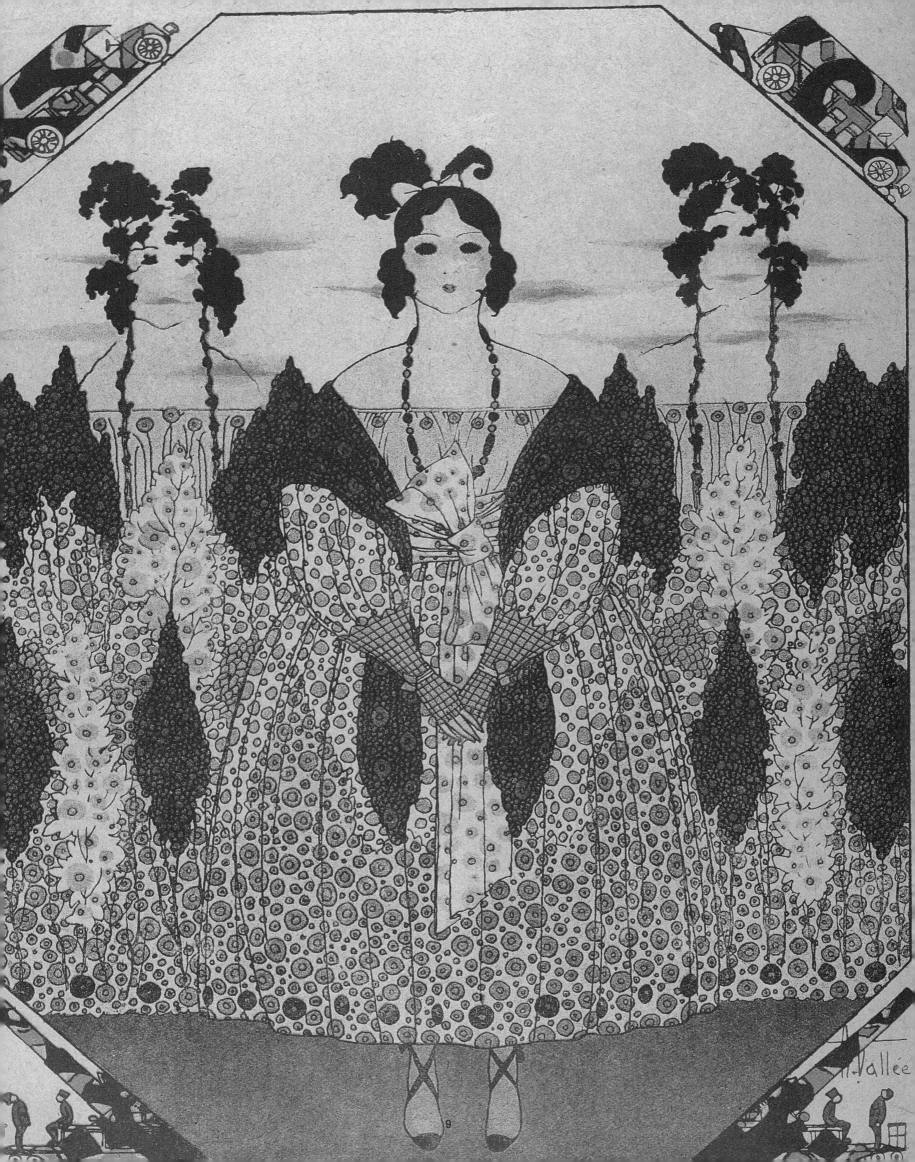

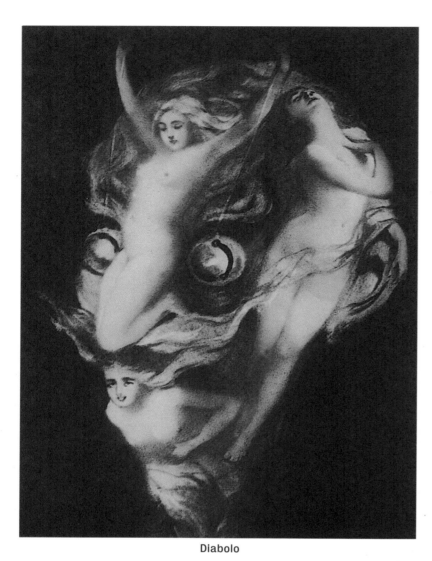

Diabolo

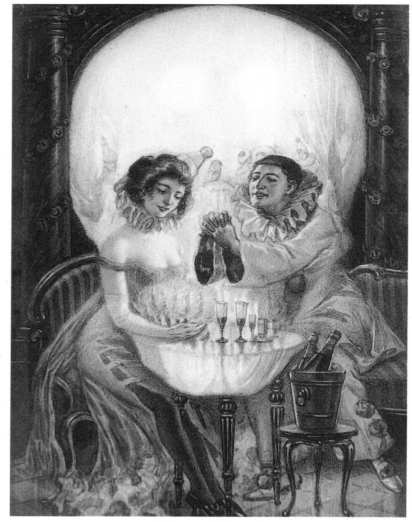

L'Amour de Pierrot

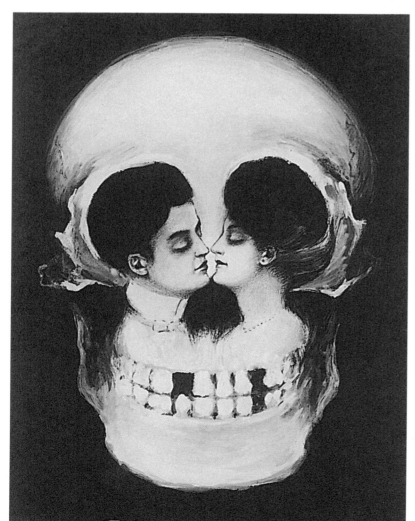

Life and Death

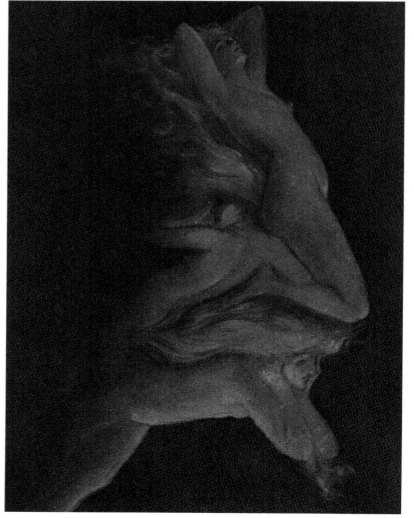

Mephisto

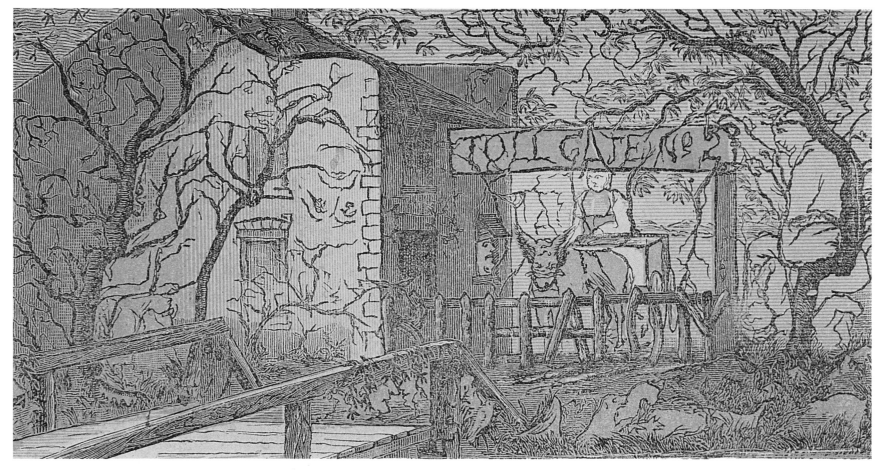

Picture containing queen, lady, traveller, hostler, clown, boy, baby, gorilla, monkey, 2 donkeys, 2 horses, elephant, bear, deer, 2 rabbits, 2 squirrels, 3 frogs, 5 dogs, otter, 2 turtles, 10 faces, 29 letters, bird, rat, 2 fish, owl

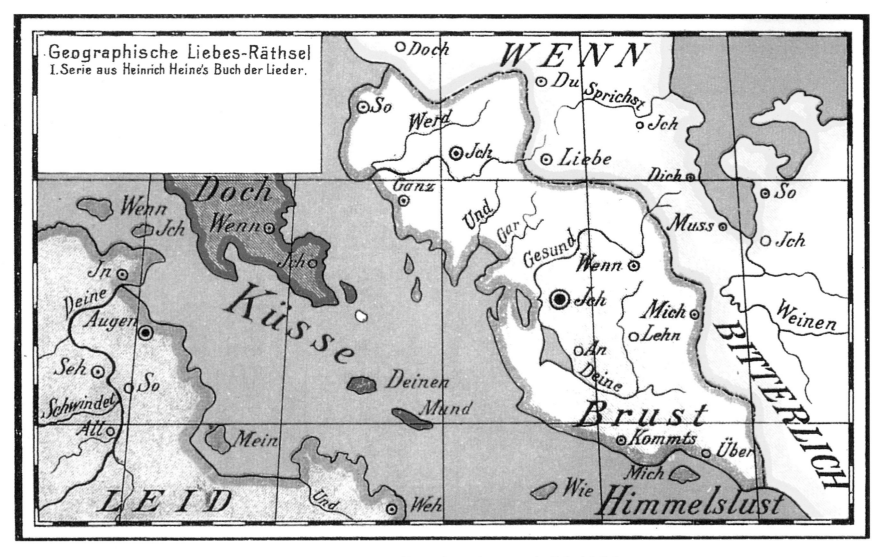

Map containing lovers' profiles and complete poem by Heinrich Heine

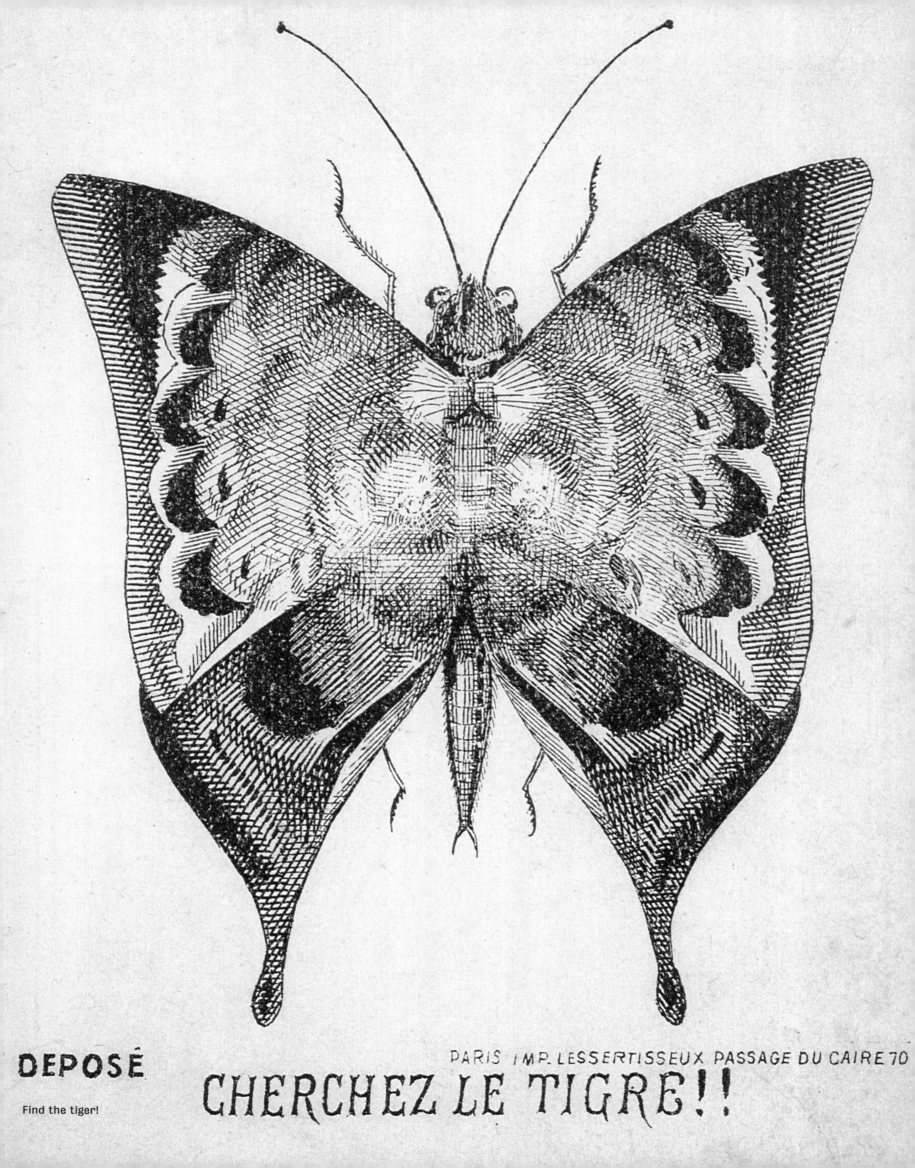

DEPOSÉ

Find the tiger!

PARIS IMP. LESSERTISSEUX PASSAGE DU CAIRE 70

CHERCHEZ LE TIGRE!!

2

MULTIPLE FIGURES

2

MULTIPLE FIGURES

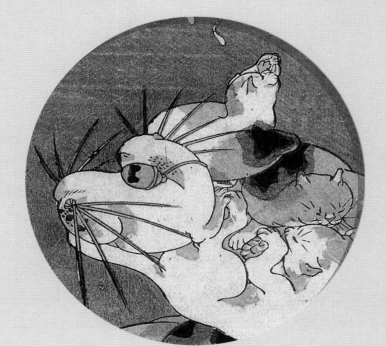

many in one
one in many
many in one
one in many

There has long been a tradition, in Japanese, Chinese and Indian graphic art, of the multiple figure in which one head belongs to two bodies. The greater the number of heads and corresponding doubling of bodies in one multiple image the more the ingenuity of the artist is admired. Sometimes these images of multiplicity were regarded as auspicious of fecundity, but more often they have been enjoyed simply for their demonstration of exuberant virtuosity and witty invention. At a deeper level they may be seen as vivid emblems of the identity that is achieved in the intense becoming as one of players in a game, musicians in a band, wrestlers in a fight, worshippers in a ceremony, soldiers in an army, dancers in a dance, or even elephants (three trunks, three tails, twelve legs) in a circus performance. Beyond that, these multiple figures, and the related composite figures (the cat that is many kittens and cats, the man that is many men), may be seen as exemplary images of the principle that all individuals contain the essential attributes of an abstract universality, and that the universal is an entity that contains the many particular instances.

one head two legs two arms
four arms four legs two heads
three heads six arms six legs
eight legs eight arms four heads
five heads ten legs ten arms
ten arms ten legs five heads
four heads eight arms eight legs
six legs six arms three heads
two heads four legs four arms
two arms two legs one head

one in many
many in one
one in many
many in one

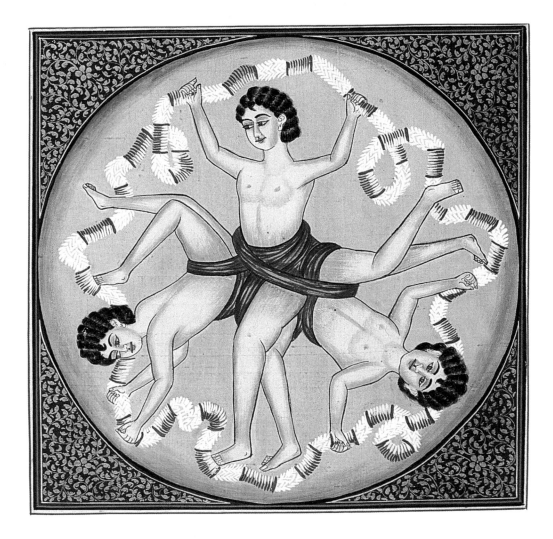

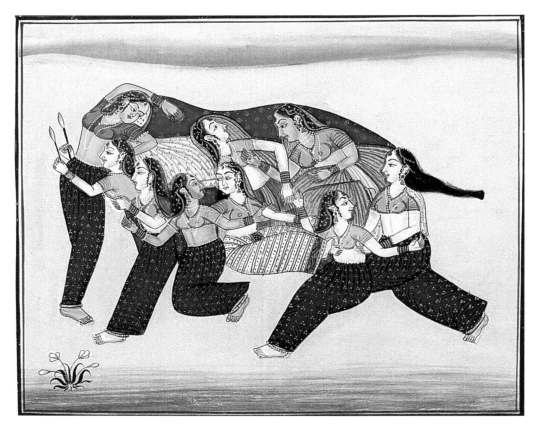

Top Three heads, six bodies *Above* One elephant, nine women
Right Cat and kittens

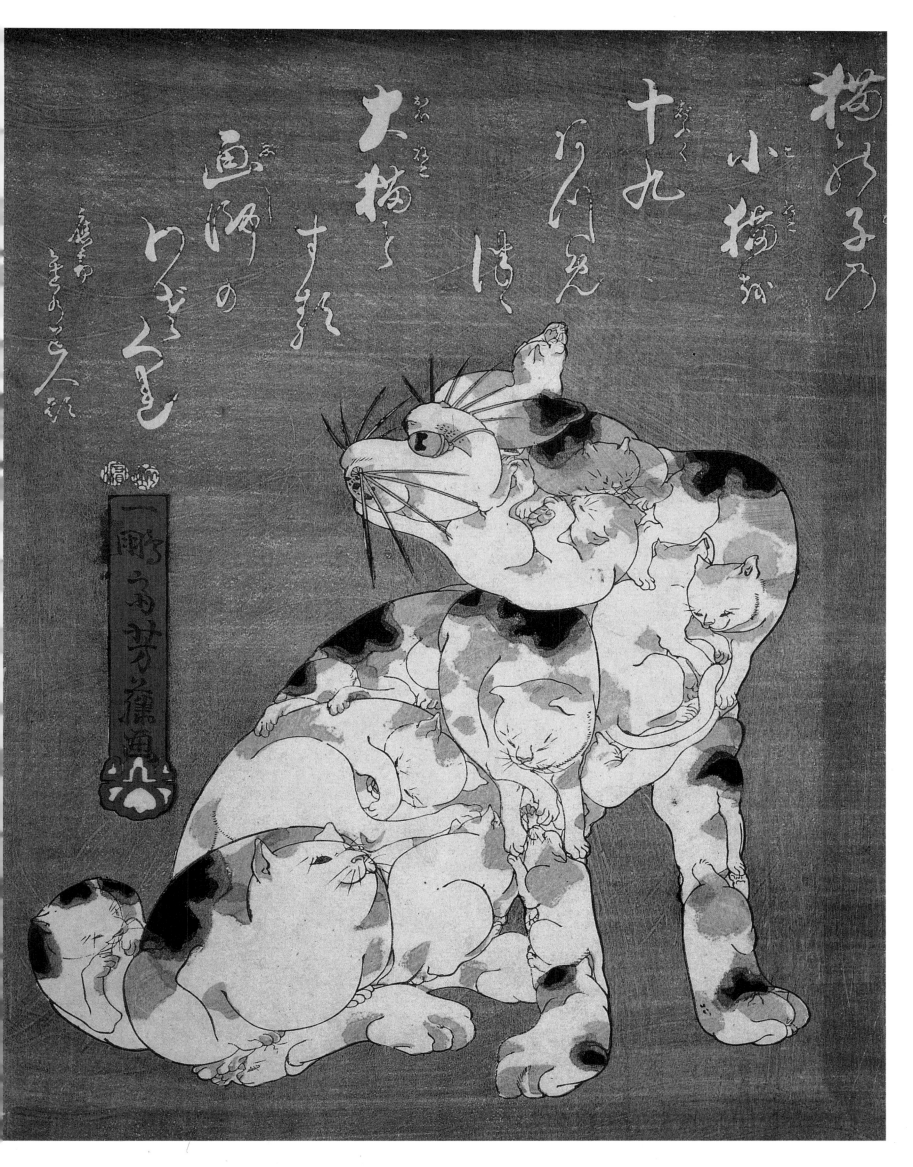

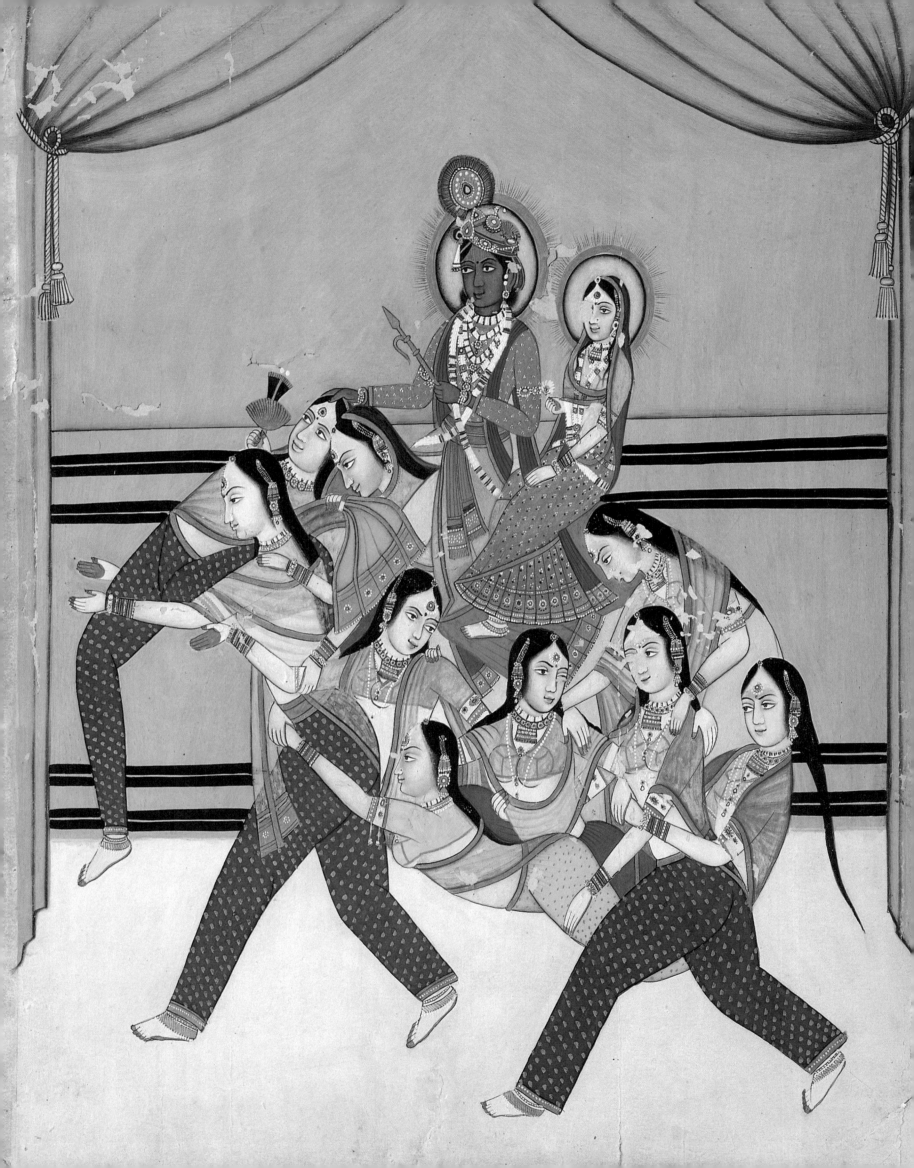

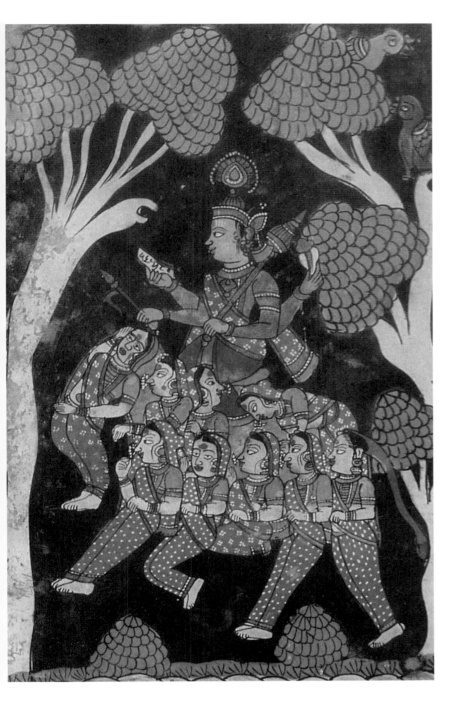

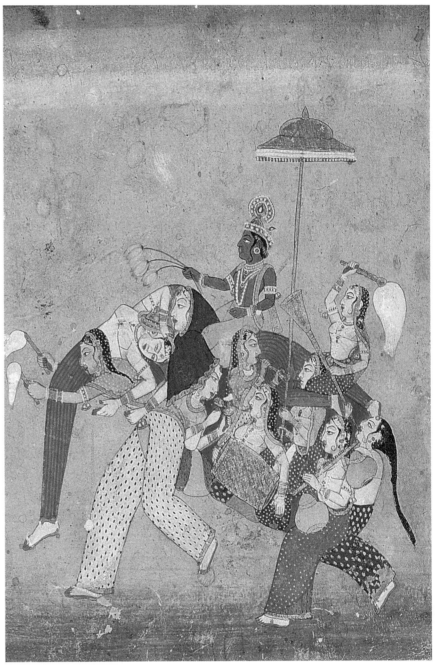

Left and above Krishna and his Gopis (milkmaids)

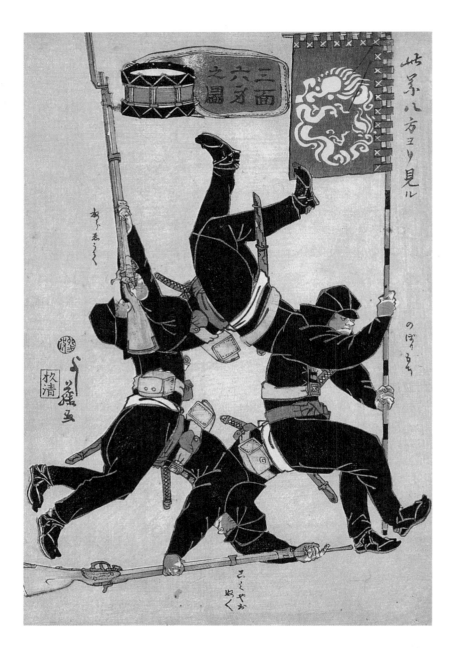

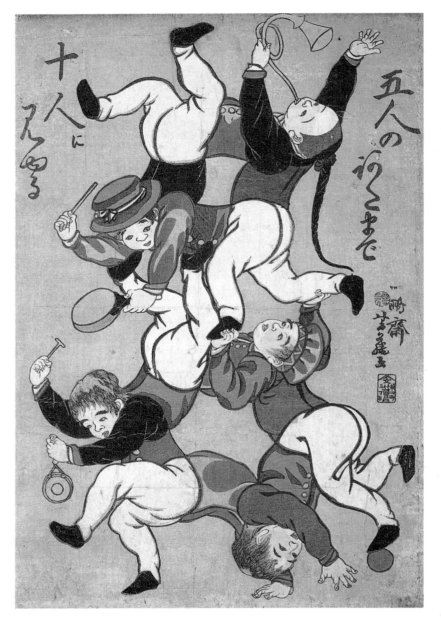

Above left Three heads, six bodies *Above right* Five heads, ten bodies
Right Two or three bodies, one head

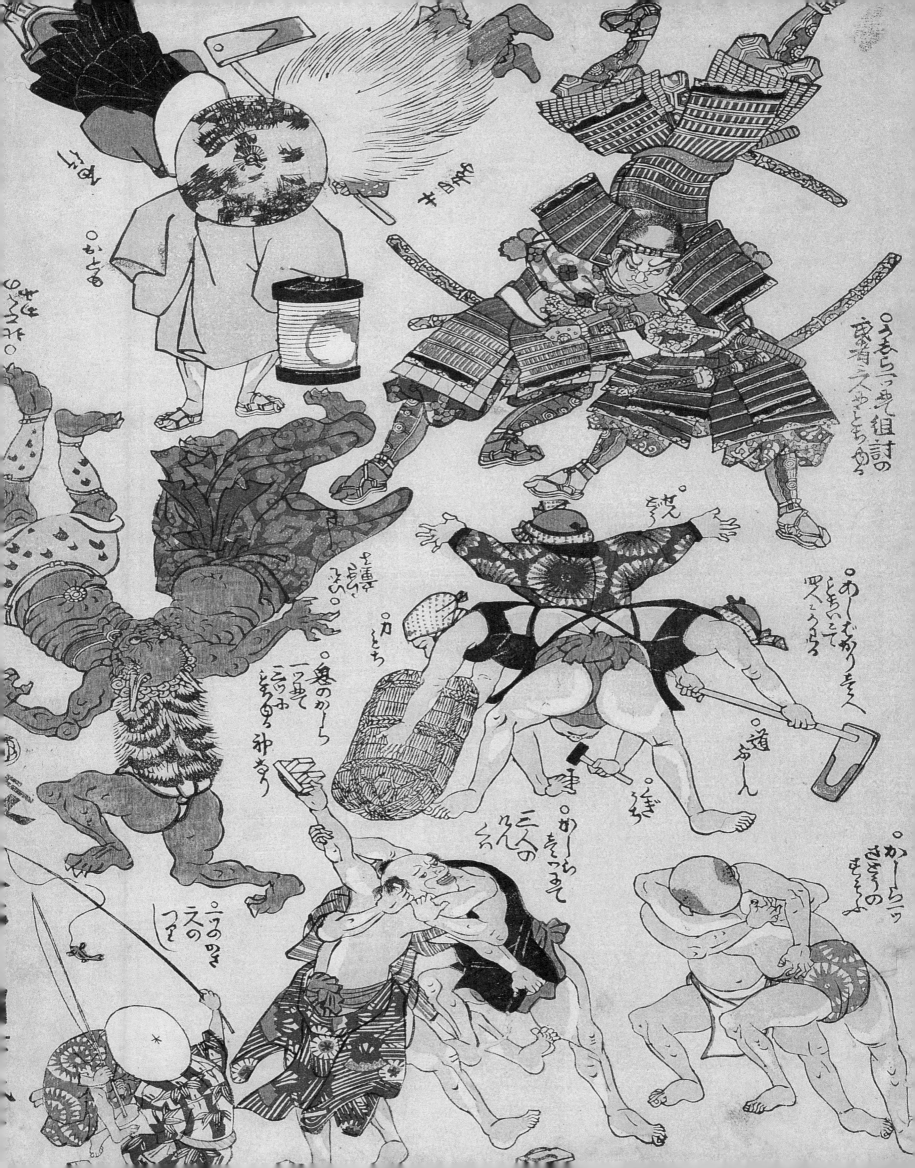

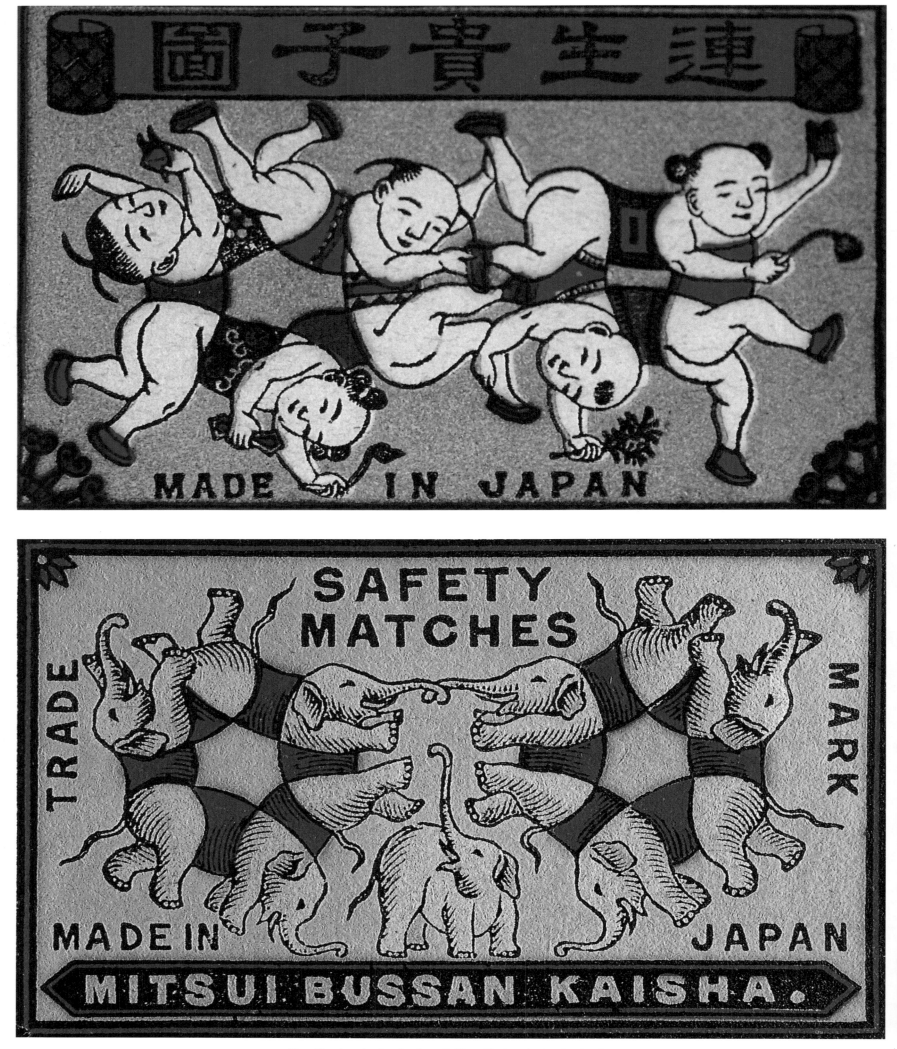

Top Five heads, ten bodies *Bottom* Six heads, twelve bodies

22

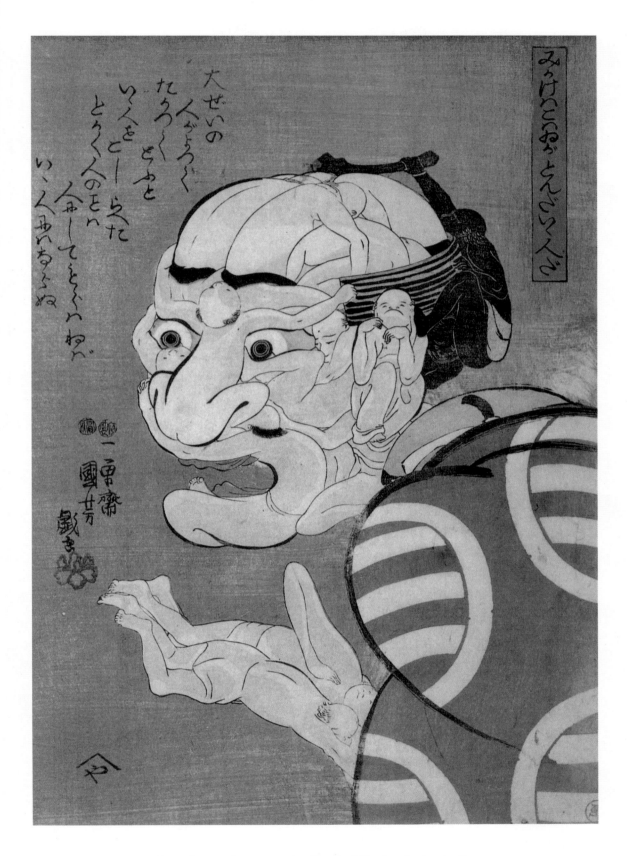

Above A man of many parts *Overleaf* Five heads, ten bodies

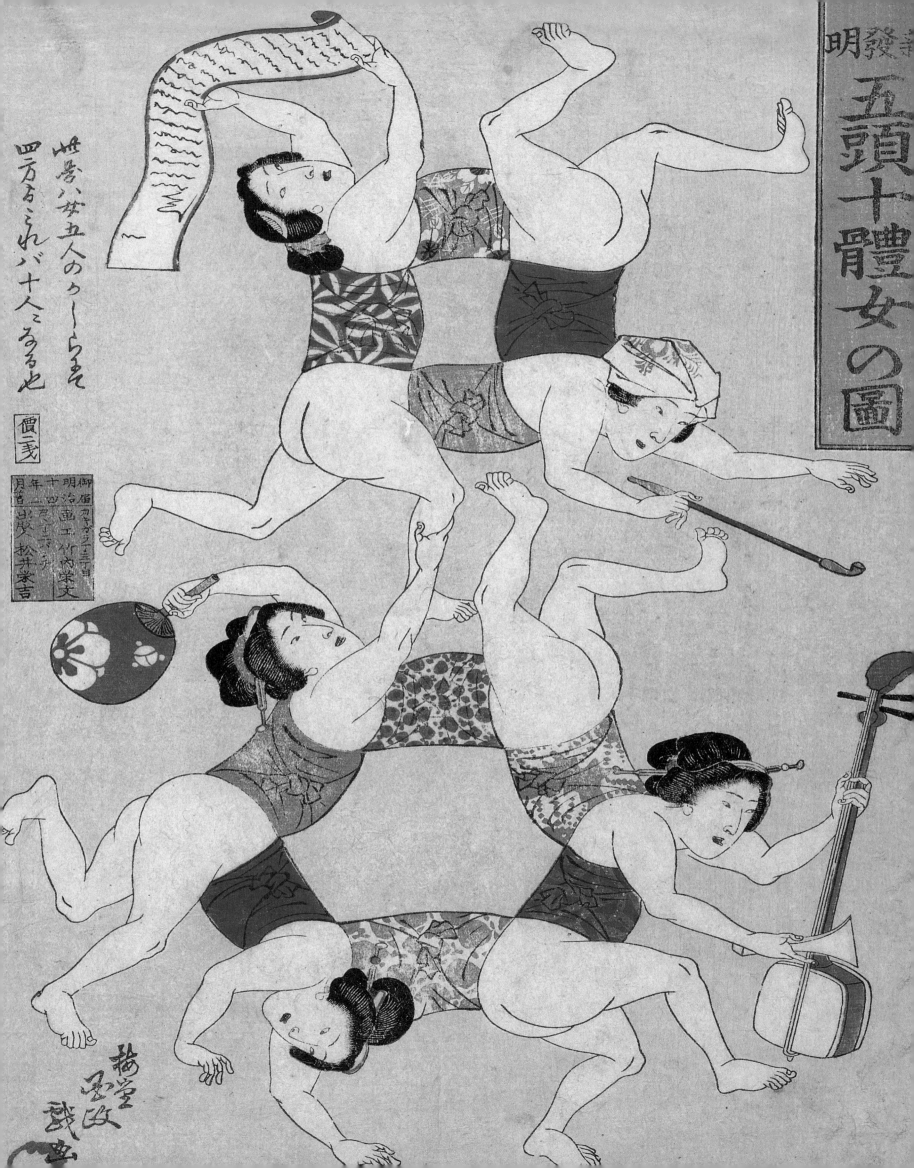

3 POLITICS

3

POLITICS

Satirical cartoons and caricatures are of course the most common visual commentaries on the perennial vagaries and calamities of politics. But there is a rich history of popular graphics, little researched and fraught with difficulties of interpretation, in which visual games, hidden images and optical conundrums treat directly of political themes. There are thin dividing lines between the categories of cartoon, caricature, and these other kinds of visual play, which may range from the most simple visual pun (a head drawn like a turnip, say) to complex Archimboldian portraits, and from adapted and fictional maps to skulls which are perhaps deliberately, perhaps quite unconsciously, prophetic. What these various categories have in common are elements of exaggeration, visual distortion, the grotesque or the macabre. Their purpose is to expose, by the implication of a transformation, the stupidity, folly, vanity or wickedness of those who possess power and misuse it.

In a concise and precise metaphorical image the graphic satirist can reduce a complex political situation to the dramatic simplicity of myth. And as in myths there is no single version. Here is Napoleon celebrated in a 1905 French postcard as military visionary; and, in a contemporary image, pictured as a monster who has turned Europe into a sea of blood, his pallid visage a ghastly amalgam of 'the victims of his folly and ambition', his military hat the wounded and shamed imperial eagle. An 1849 German map-image presents eastern Europe as a sick old man, still under threat a year after the Year of Revolutions; in 1904, Imperial Russia is seen through Japanese eyes as a rapacious but over-reaching octopus. Two years later a portrait of the Russian Imperial family is assimilated to a skull in what is at once an indictment of deathly political reaction and an uncanny prefiguring of the family's annihilation twelve years later.

In October 1939, the tense first days of the Second World War, *Match*, 'the weekly magazine of world-wide actuality', commissioned a cover from Salvador Dali, Surrealist inventor of

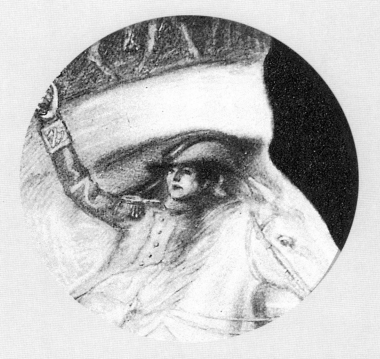

the 'paranoiac-critical method'. This method entailed the discovery or creation of images in which objects dissolve, solid things become transparent, and nothing has a stable shape or identity. These metamorphoses (like those in Dali's paintings) have a basis in that kind of hallucination whereby one sees, and persuades others to see, all sorts of shapes in a natural object: for example, a camel, a weasel or a whale in a cloud. According to Dali's mad logic, journalistic 'actuality' is no more than just such subjective projection, for the world is in a constant state of deliquescent uncertainty. This dream-like view of things may have seemed entirely appropriate to the unreal 'in-between days' at the beginning of the War.

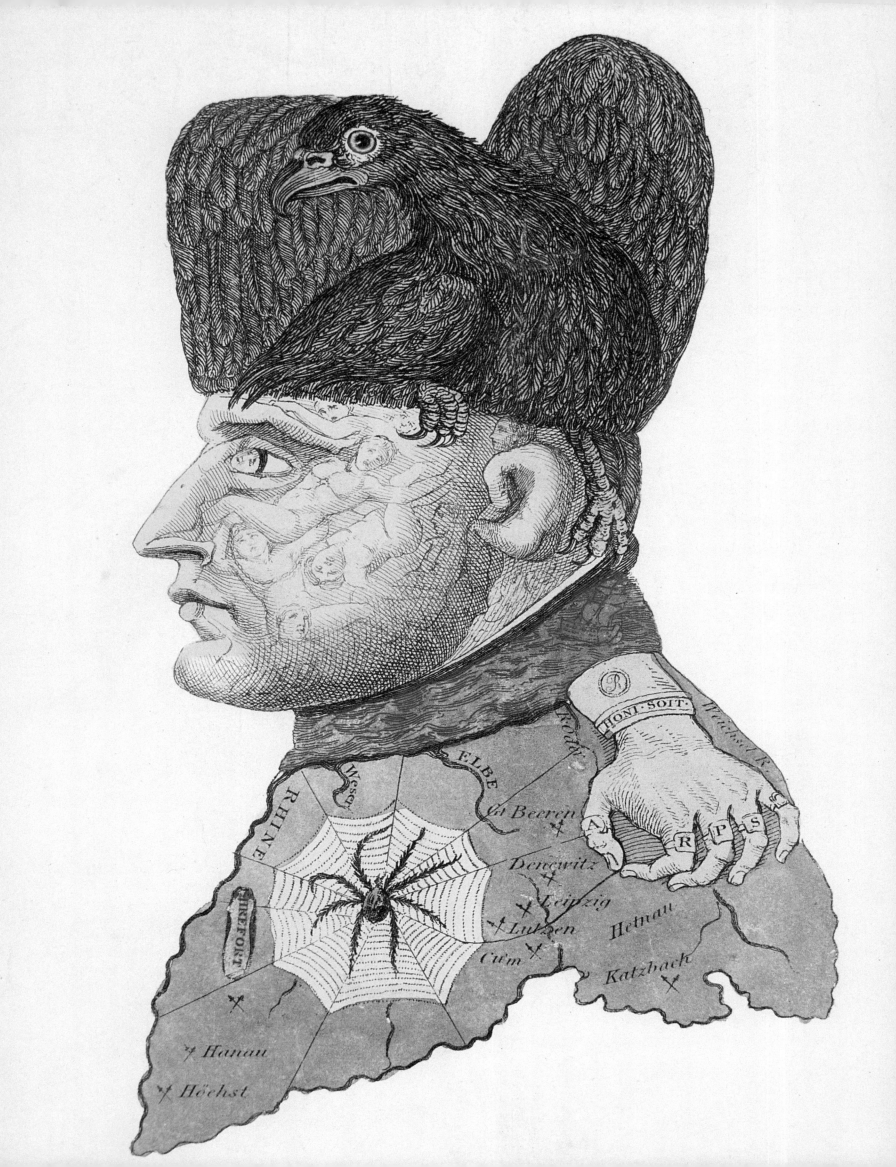

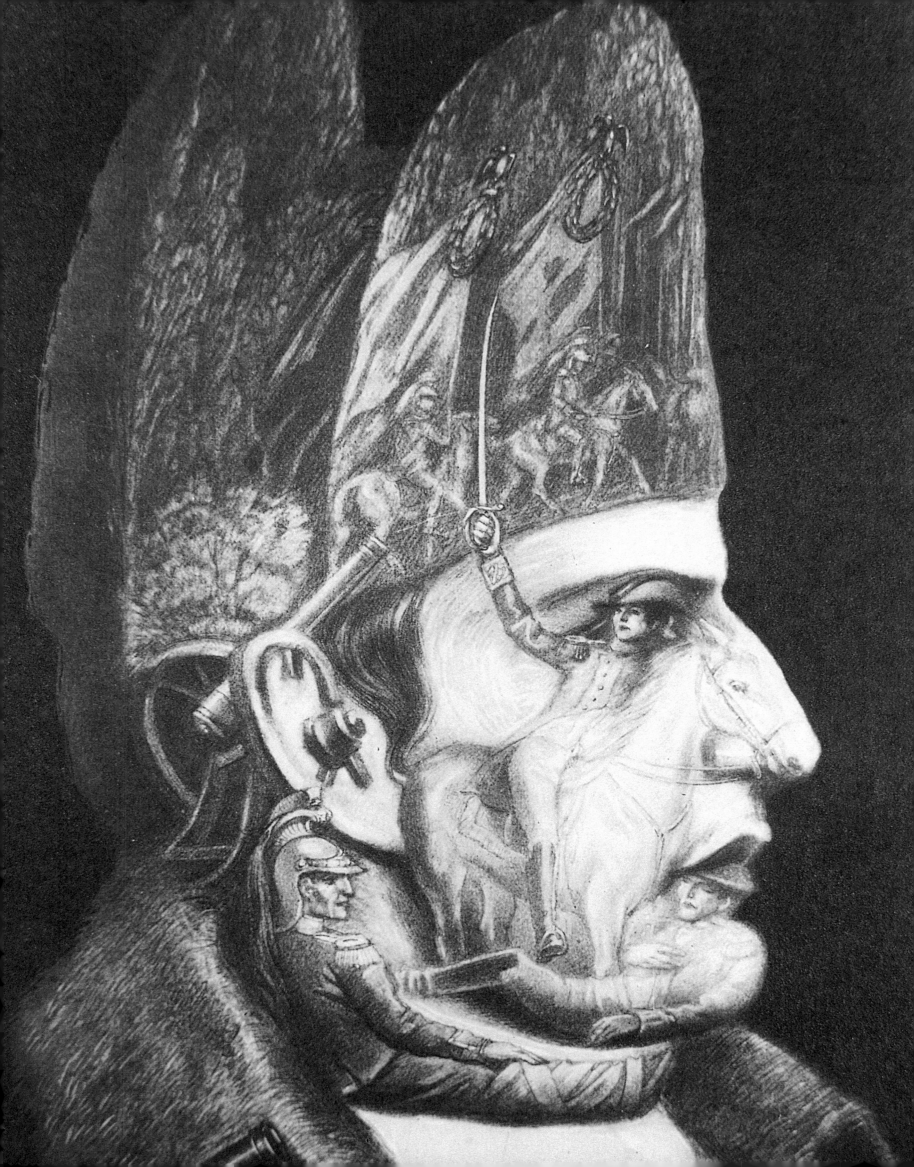

'Black Octpus' is a name newly given to Russia by a certain prominent Englishman. For the black octpus is so avaricious, that he stretches out his eight arms in all directions, and seizes up every thing that comes within his reach. But as it sometimes happens he gets wounded seriously even by a small fish, owing to his too much covetousness. Indeed, a Japanese proverb says: "great avarice is like unselfishness." We Japanese need not to say much on the cause of the present war. Suffice it to say, that the further existence of the Black Octpus will depend entirely upon how he comes out of this war. The Japanese fleet has already practically annihilated Russia's naval power in the Orient. The Japanese army is about to win a signal victory over Russia in Corea & Manchuria. And when............. St. Petersburg? Wait & see! The ugly Black Octpus! Hurrah! Hurrah! for Japan.

March, 1904. Kisaburo Ohara.

亞

R U

著作權所有

全明治三十七年二月廿三日印刷
年全月廿八日發行

第四版

印刷所 東京市
發賣元 一元
東京市

太西洋 ATLANTIC OCEAN

GREAT BRITAIN

NORWAY

瑞典 SWEDEN

那

芬蘭 FINLAND

DENMARK

HOLLAND
BELGIUM
LUXEMBURG

獨 GERMANY

波蘭 POLAND

佛蘭西 FRANCE

SWITZERLAND

太利 AUSTRIA

匈牙利 HUNGARY

CREMIA

裏海 CASPIAN SEA

アフガニスタン

黑海 BLACK SEA

土耳古 TURKEY

波斯 PERSIA

西班牙 SPAIN

PORTUGAL

ITALY

CORSICA

POPE

MONTENEGRO
SERVIA

BULGARIA
RUMANI

BOSPORAS

SARDINIA

SICILY

GREECE

亞剌 ARABIA

地中海 MEDITERRANEAN SEA

CRETE

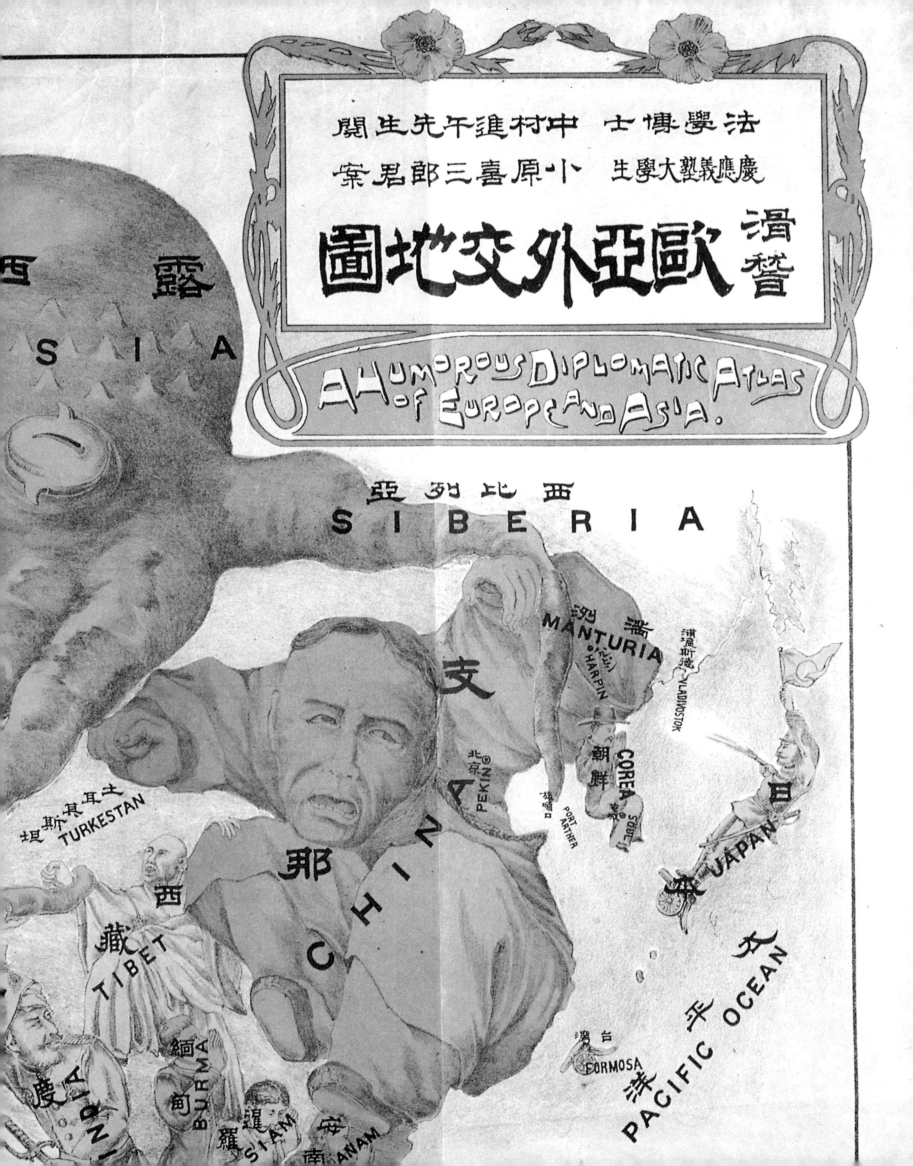

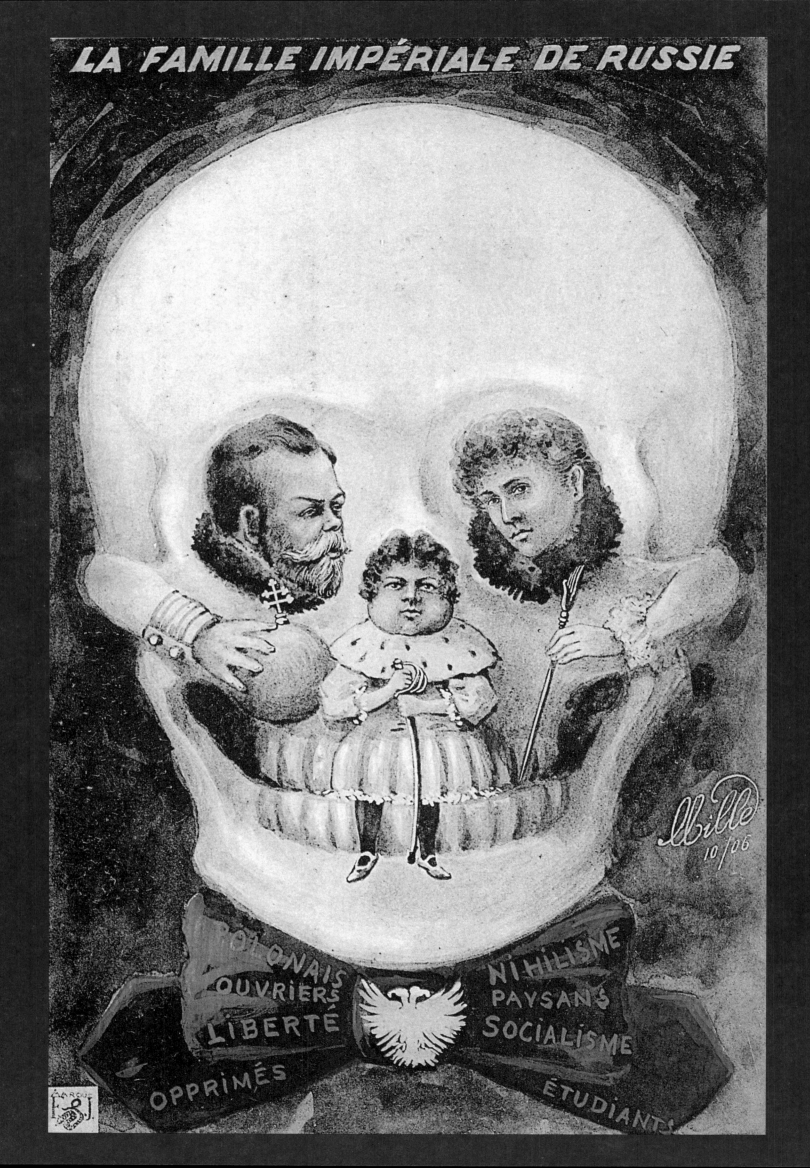

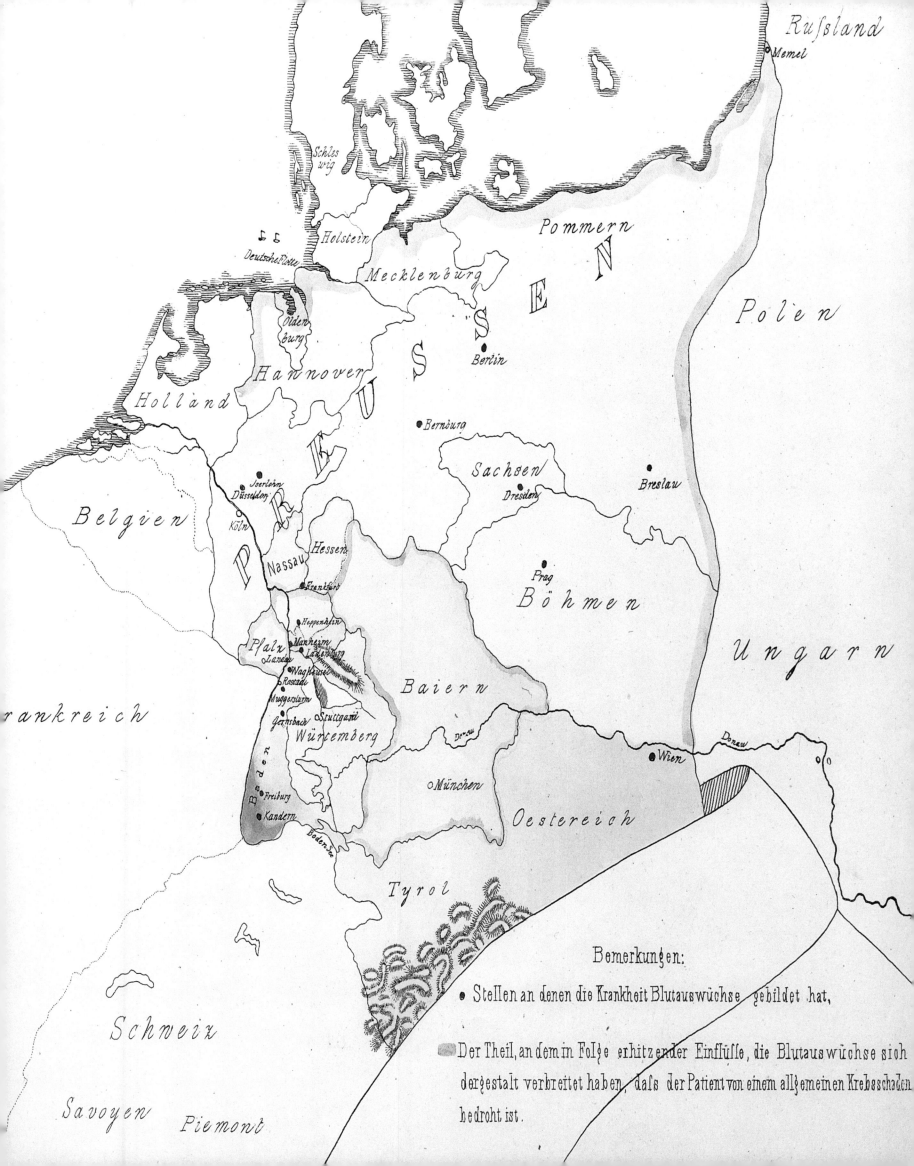

Rußland

Memel

Schleswig

Holstein

Deutsche Flotte

Pommern

Mecklenburg

P R E U S S E N

Polen

Oldenburg

Hannover

Berlin

Holland

Bernburg

Sachsen

Breslau

Iserlohn

Düsseldorf

Dresden

Belgien

Köln

Nassau

Hessen

Frankfurt

Prag

Böhmen

Ungarn

Heppenheim

Pfalz

Manheim

Landau

Ladenburg

Waghäusel

Rastadt

Muggersturm

Gernsbach

Stuttgart

Würtemberg

Baiern

Donau

Wien

Donau

Baden

München

Freiburg

Oestereich

Frankreich

Kandern

Bodensee

Tyrol

Schweiz

Bemerkungen:

● Stellen an denen die Krankheit Blutauswüchse gebildet hat,

▨ Der Theil, an dem in Folge erhitzender Einflüsse, die Blutauswüchse sich dergestalt verbreitet haben, dass der Patient von einem allgemeinen Krebsschaden bedroht ist.

Savoyen Piemont

VOL. 26 NO. 657 MAY 19 1894 PRICE 10 CENTS

Judge

ENTERED AT THE POST OFFICE AT NEW YORK AS SECOND CLASS MATTER, COPYRIGHT 1894 BY THE JUDGE PUBLISHING CO. TITLE REGISTERED AS A TRADE MARK.

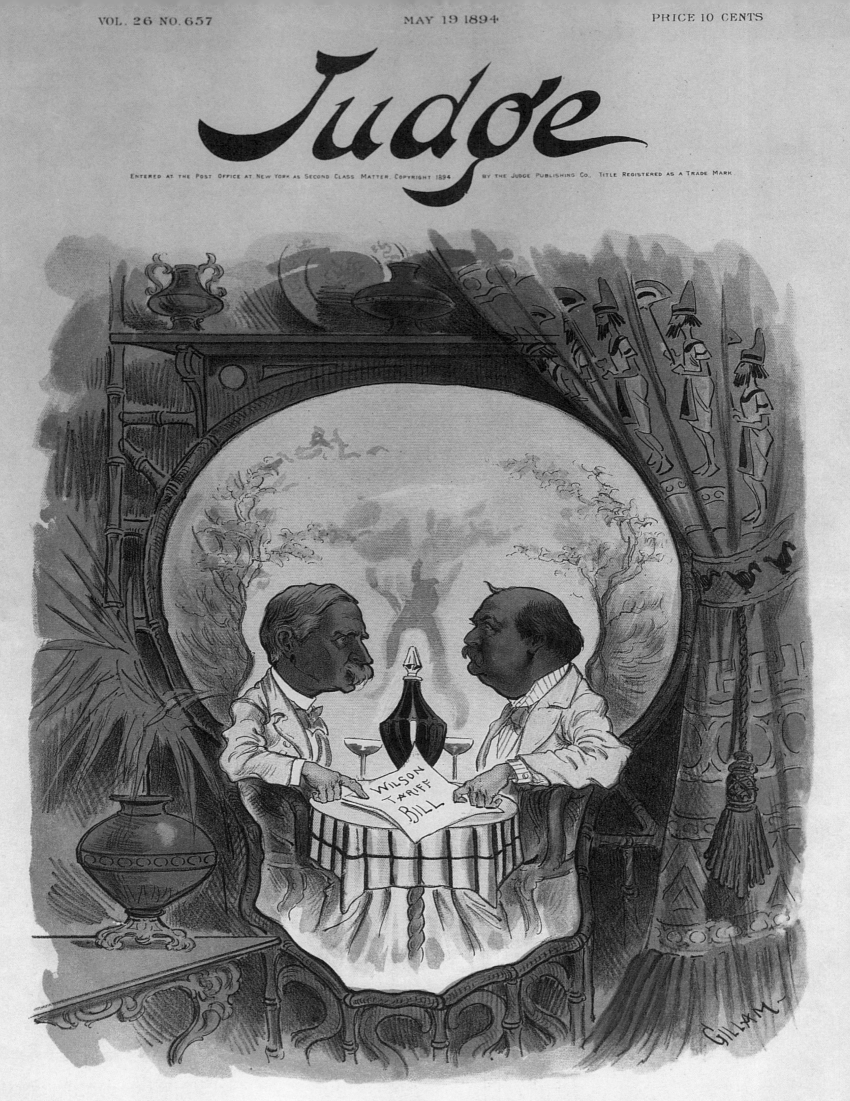

DEATH TO OUR INDUSTRIES!
That is what the Cleveland-Wilson conspiracy means.

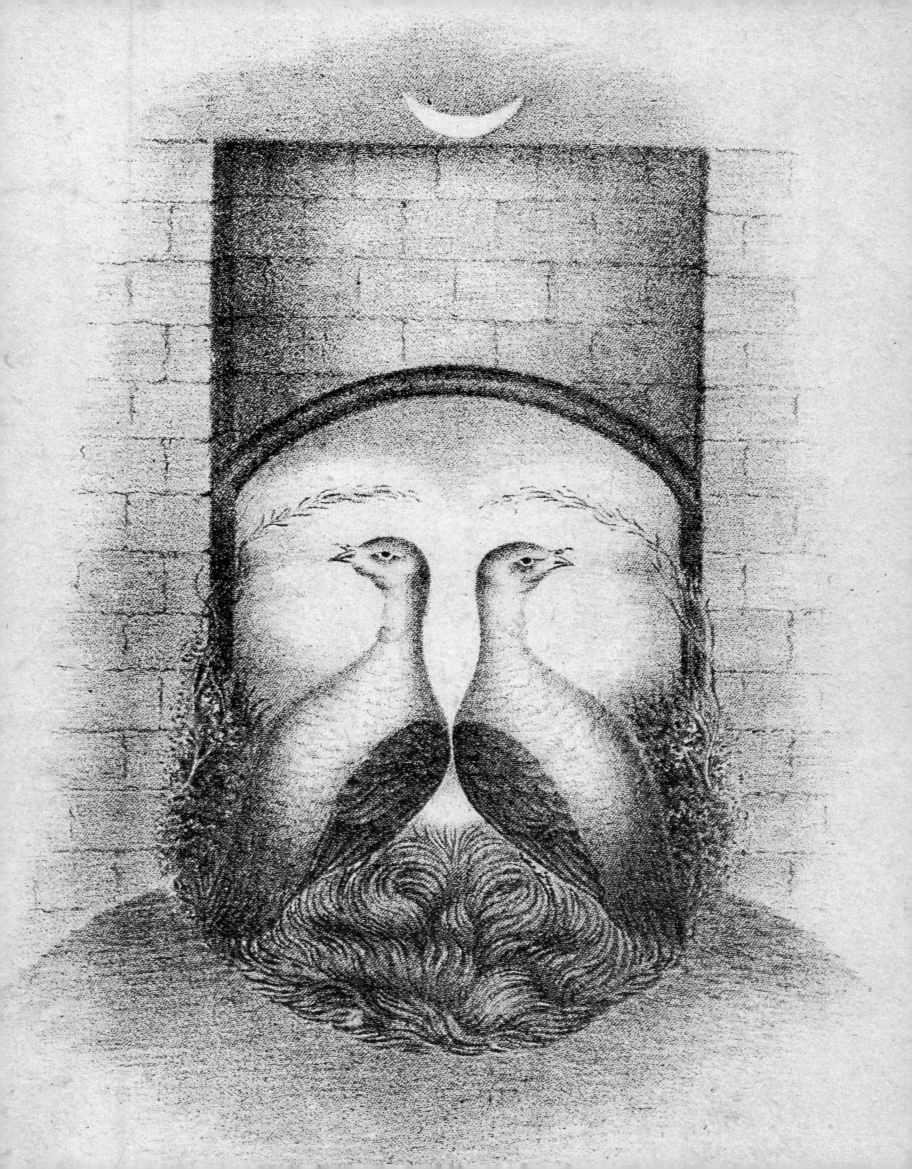

MATCH

4

UPSIDE-DOWNS

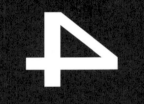

4

UPSIDE-DOWNS

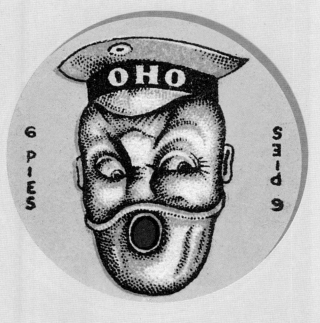

The 'upside-down' has been a popular visual device since the early nineteenth century. It depends for its effect upon there being a contrasting image presented to the eye when the support (a printed sheet, a postcard, a magazine cover, a matchbox) is turned in 180°.* As with many popular visual tricks it is often deployed to no more serious purpose than to amuse or to attract attention to a product or a firm. (Matchboxes are a wonderful throwaway medium for graphic play by unknown artists the world over.) But the upside-down's widespread popularity (the Japanese especially enjoy them) has, as always in such a case, a basis in something more than the simple enjoyment of visual trickery. It turns upon our recognition of those contraries that are universal to human experience, and which are given emblematically succinct expression in these upside-down dual images: sex and age distinctions (youth/girl, man/woman, young/old), moral dichotomies (good/evil, benign/malign), emotional polarities (joy/grief, love/hate), and disparities of mood (care-worn/care-free, happy/sad).

What the upside-down does is to confound or counter the certainties of what E.H. Gombrich called 'physiognomic perception', that faculty which responds with immediate conviction to a human face, discerning condition, character, emotion and mood; for the upside-down face contains its physiognomic contrary, and we anticipate the contradiction. Things are not what they seem; or rather, we can never be certain they are the right way up, or the *only* way up. An image such as that which purports to expose the fraudulence of the post-war Italian Popular Front of Communists and Socialists (FRO. DE. POP.; frode = fraud) utilises this contradictory effect to political ends: turn the image upside-down and we see which way up things really are: Garibaldi is a benign front for the evils of Stalin.

The Way of the World does not conform to this definition, for its ingenuity consists in the fact that it reads the same way downside up. It is, in fact, a rare instance of a musical *palindrome*, just as playing cards are, in effect, visual palindromes.

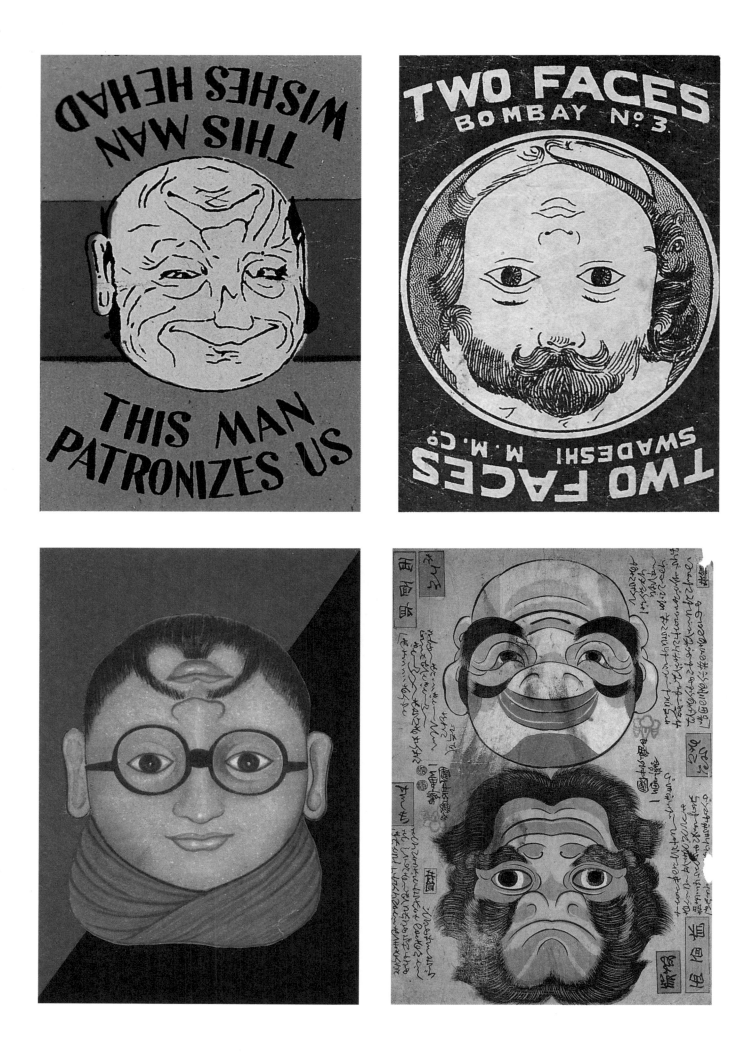

43

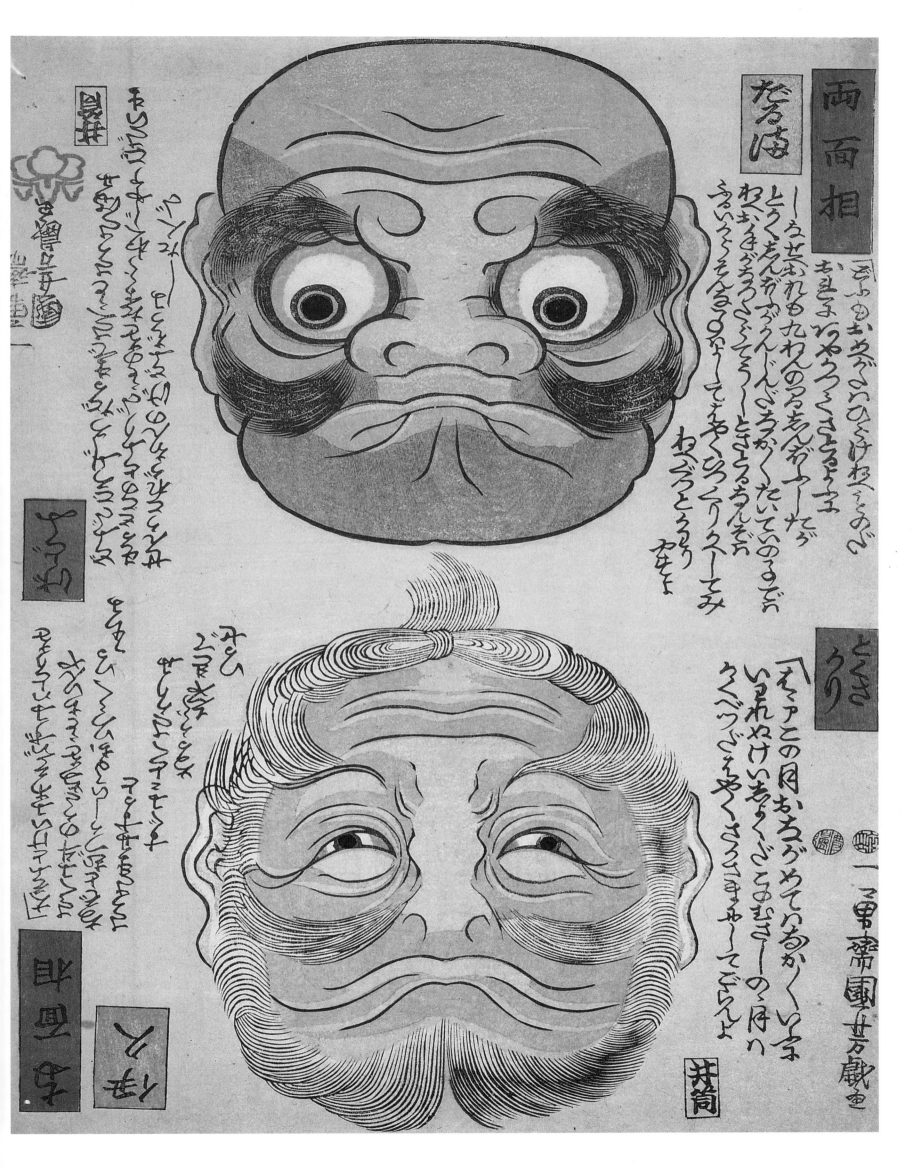

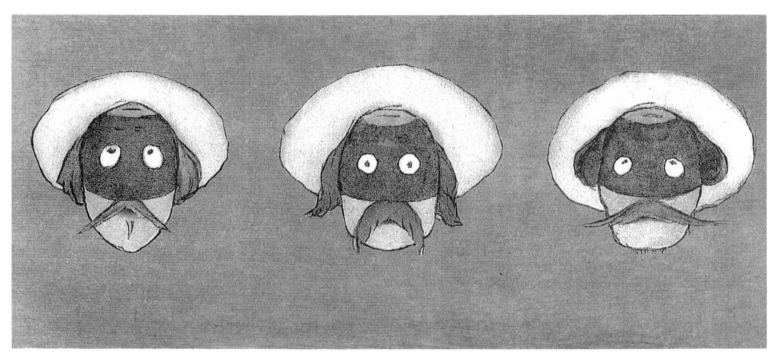

THE WAY OF THE WORLD

MOSCHELES

Allegro

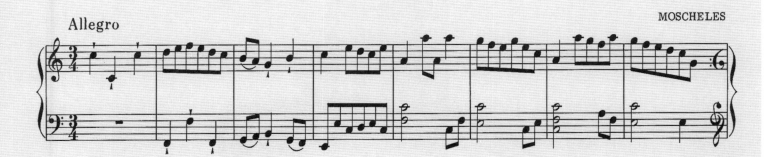

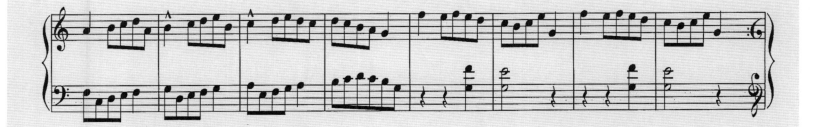

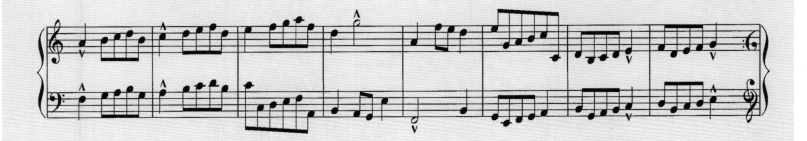

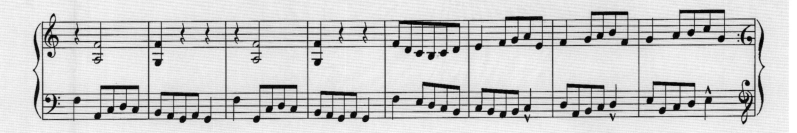

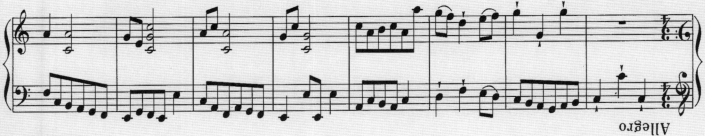

MOSCHELES

Allegro

THE WAY OF THE WORLD

FRO. DE. POP.

W il fronte democratico?

capovolgi e vedrai la frode

5

OPTICAL ILLUSIONS

5

OPTICAL ILLUSIONS

The eye, as we say, plays tricks upon the mind. Actually, of course, it is the other way round. For it is the mind that organises the data that the eye supplies. The eye is the organ of perception; it knows nothing but what the mind tells it. Light reflected from objects enters through the pupil of the eye and registers an upside-down configuration upon the retina, which transmits this to those centres of the brain that interpret this sense-data, turn it the right-side-up and transform it into visual information. But the mind (which is the brain-in-action, processing sense-data and supplying knowledge – information already stored – to enable its effective interpretation) uses other clues, it remembers things similar to those now being seen and it brings this knowledge into play. For example, let us say, it 'sees' (for it is the *mind* that 'sees') an upside-down face (the eye registers the colour, line and texture of the picture, transmits this to the brain, and the brain interprets: this is an upside-down face); if this were the first time, it would be fooled, so to speak, and would interpret simply thus: this is a face. But it knows the trick (it has *recognised* a convention) and this knowledge means that it anticipates the inverted contrary.

Optical illusions work, in most cases, by doubly deceiving the mind. The eye supplies true data, a configuration of elements (lines and figures of equal length, say, or a series of black concentric circles, or twenty-seven diamonds, nine of each colour, blue, cream and black); the brain interprets them (as columns in a gallery, or as two- or three-dimensional geometric figures, or as the wheel of a motor car). That is the first level of illusion, which enables the mind to recognise the image as relating to the actuality of known things in the world. But the mind goes further, supplying knowledge from memory of similar things (in other pictures and in the world of actualities) and proceeds to make false assumptions based on clues in the image (the perspective of the gallery, to which the windows conform; the off-centre foreground column that obscures the aligned points of the chapel arches, the down-light on to the nine cubes, the diagonal line, in a diagram or picture, that appears to describe recession, etc.).

When measurement supplies it with objective information, or when the brain tells the eye what is actually the case, the mind is delighted in its acknowledgement of error. That's something that can't be explained.

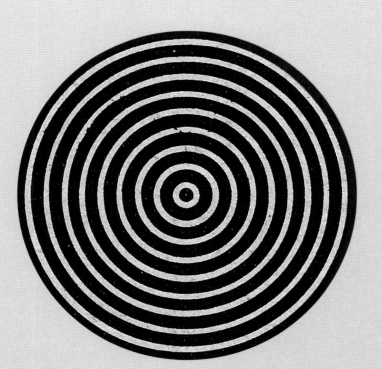

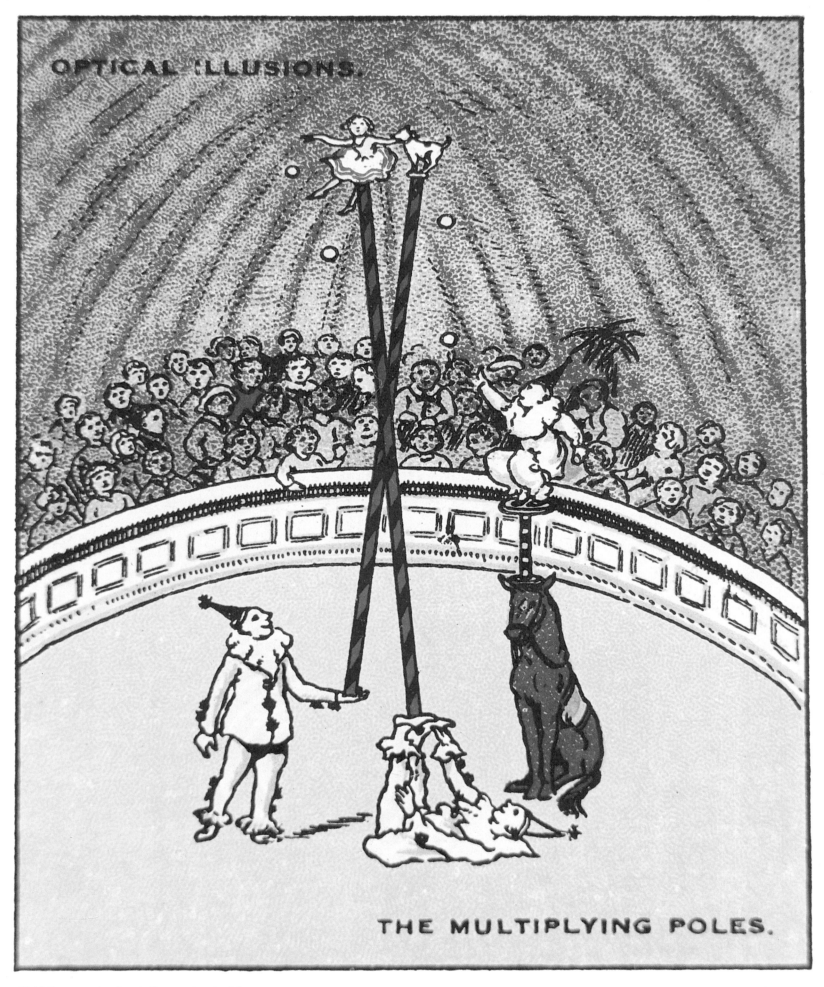

OPTICAL ILLUSIONS.

THE MULTIPLYING POLES.

Hold the page horizontally on a level with your eyes. Then tilt it slightly so that you are looking along the picture from bottom to top. Watch the poles closely and you will then see more of them than are really there.

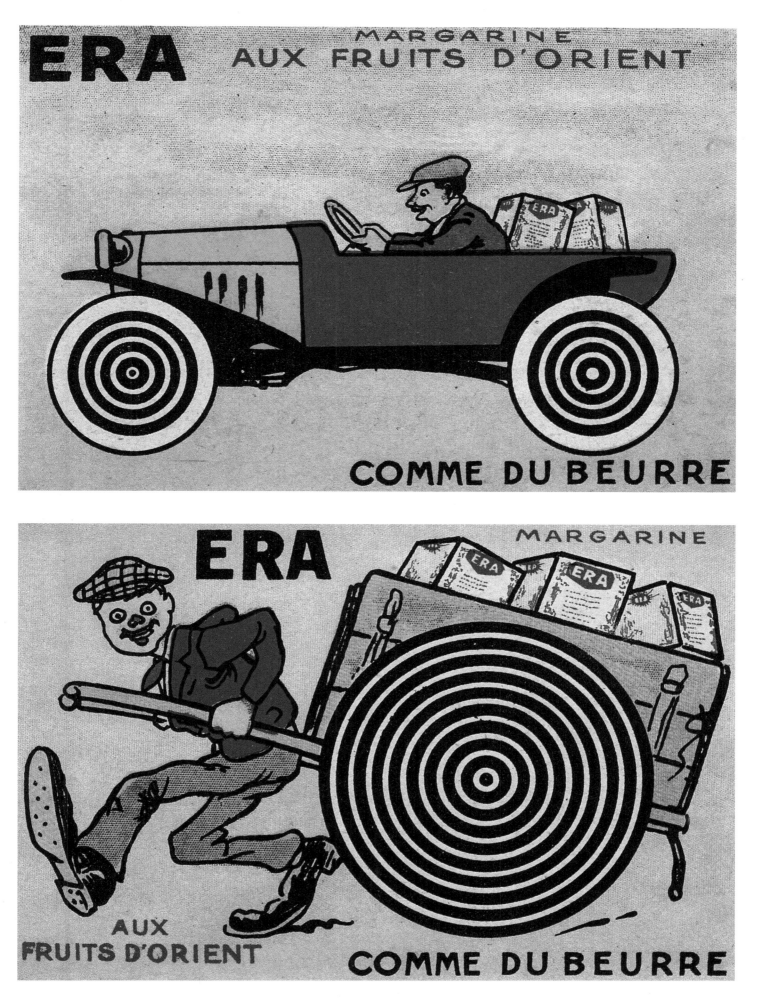

Rotate the page to see the wheels turn

Above Spots on the moon Right A calligraphic mystery

SECOND VIEW

FIRST VIEW

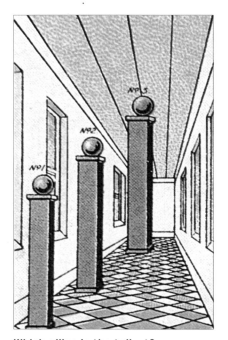

Which pillar is the tallest?

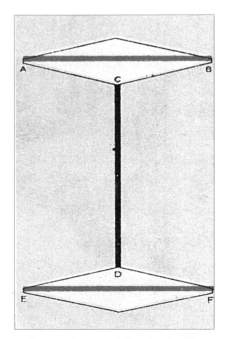

Is the vertical black line longer than the horizontal red lines?

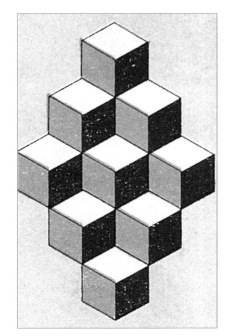

Nine cubes or only four?

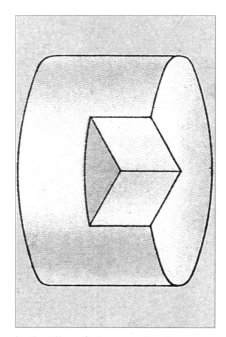

Is the slice of cheese cut out or stuck on?

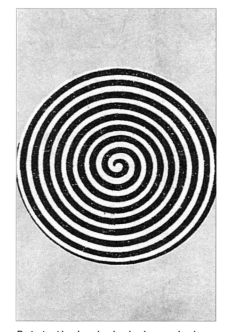

Rotate the book clockwise: spiral or concentric circle?

Are lines AB and BC equal?

Are these circles or hexagons?

Are the bricks straight and parallel?

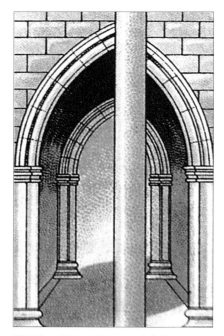

Will the sides of the arch join up correctly?

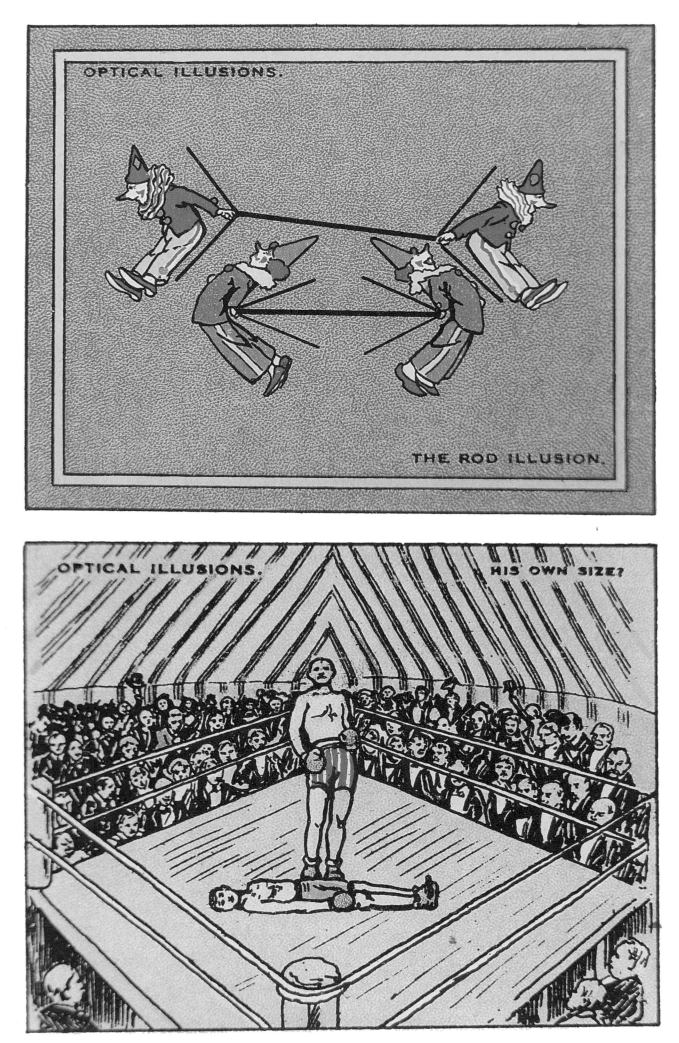

Top Which rod is longer? *Above* Which boxer is the tallest?

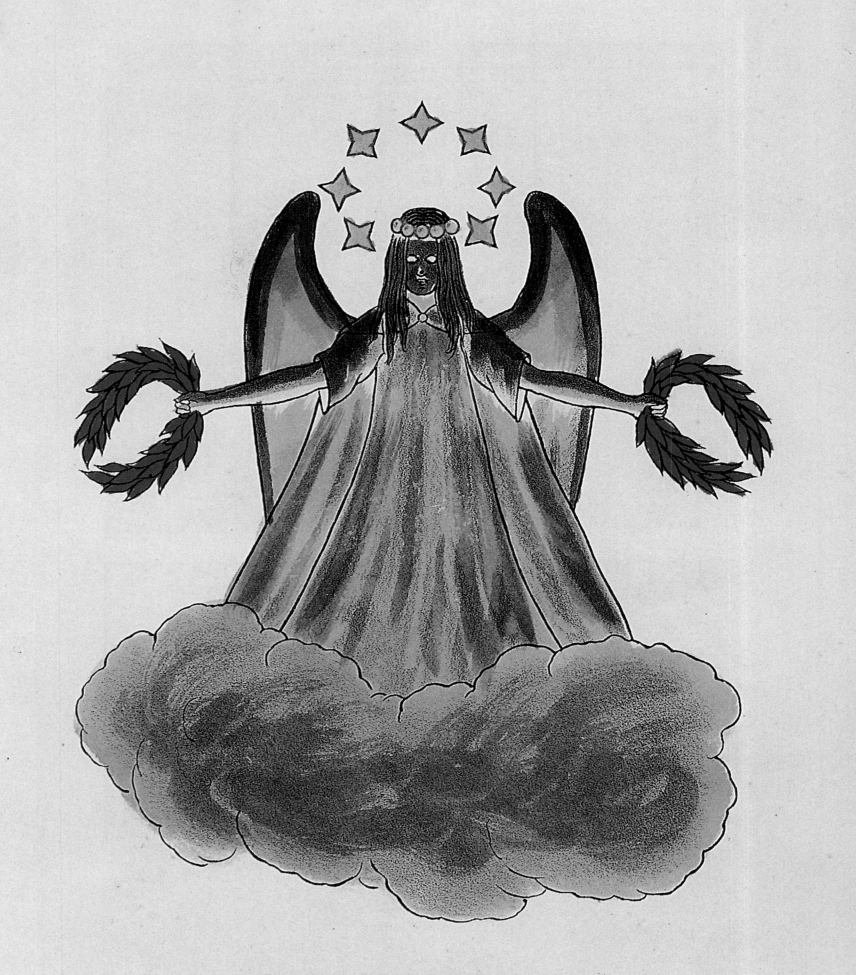

Stare at the angel's head for twenty seconds – then focus
your eyes steadily on a plain white surface and the ghost will appear

6

HIDDEN PROFILES

We are accustomed to the idea that flowers may be used as emblems and signs; we even speak of the 'language of flowers', in which individual species carry quite specific meanings, and combinations in a bouquet might carry coded messages. Flowers play a part in the rituals of love and friendship, marking special occasions; we give flowers to express thanks, to express contrition, to signify forgiveness. We give or carry flowers at moments of enhanced significance in life, using them as adjuncts at the celebration of rites of passage, at birth, marriage and death. We love flowers, and their associations for us are (in almost all cases) positive. So it is not surprising that they figure in a popular version of the hidden image that enjoyed a great vogue in the early years of the nineteenth century. This visual game of hiding the profiles of political figures in sprays of flowers (or in the branches and leaves of trees) was a way of simultaneously conveying support and celebrating them by floral association. Sometimes there was a further significance in the specific choice of the flower or tree.

Napoleon's assurance to his supporters, on being exiled to Elba, that he would return in the Spring – 'the violet season' – was celebrated in the display of bunches of violets, and in numerous prints of the flower with his profile hidden in them; in a print from 1815 the Emperor and his family are hidden in a beautiful spray of white lilies, the national flower. The choice of 'The Pop'lar Tree' in the satirical pro-Reform print of 1831 depends upon a simple pun, and on the discovery of four proponents of the Reform Bill (and the reluctant monarch) in its foliage. Quite apart from their hidden profiles, these engravings are among the most delightful popular images of their time.

Above Find eight profiles
Right Find five profiles

62

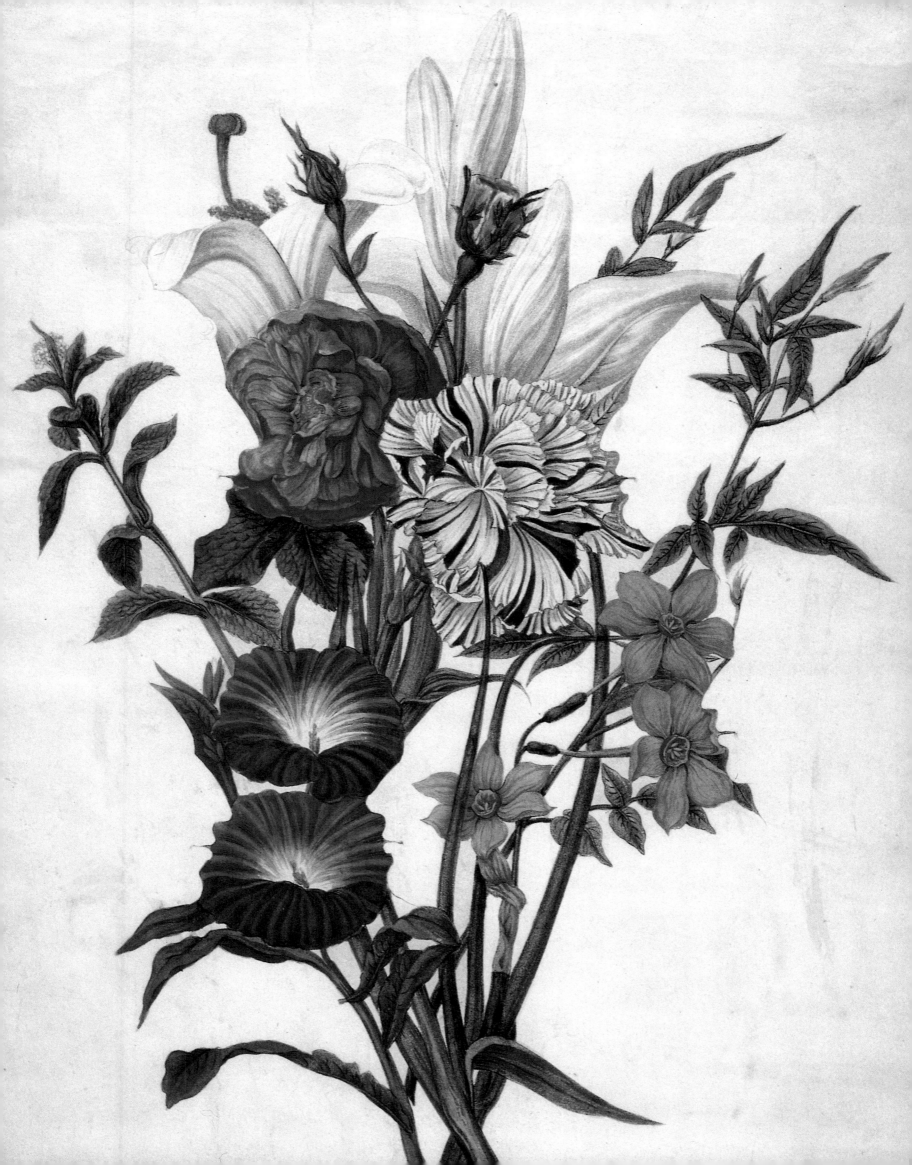

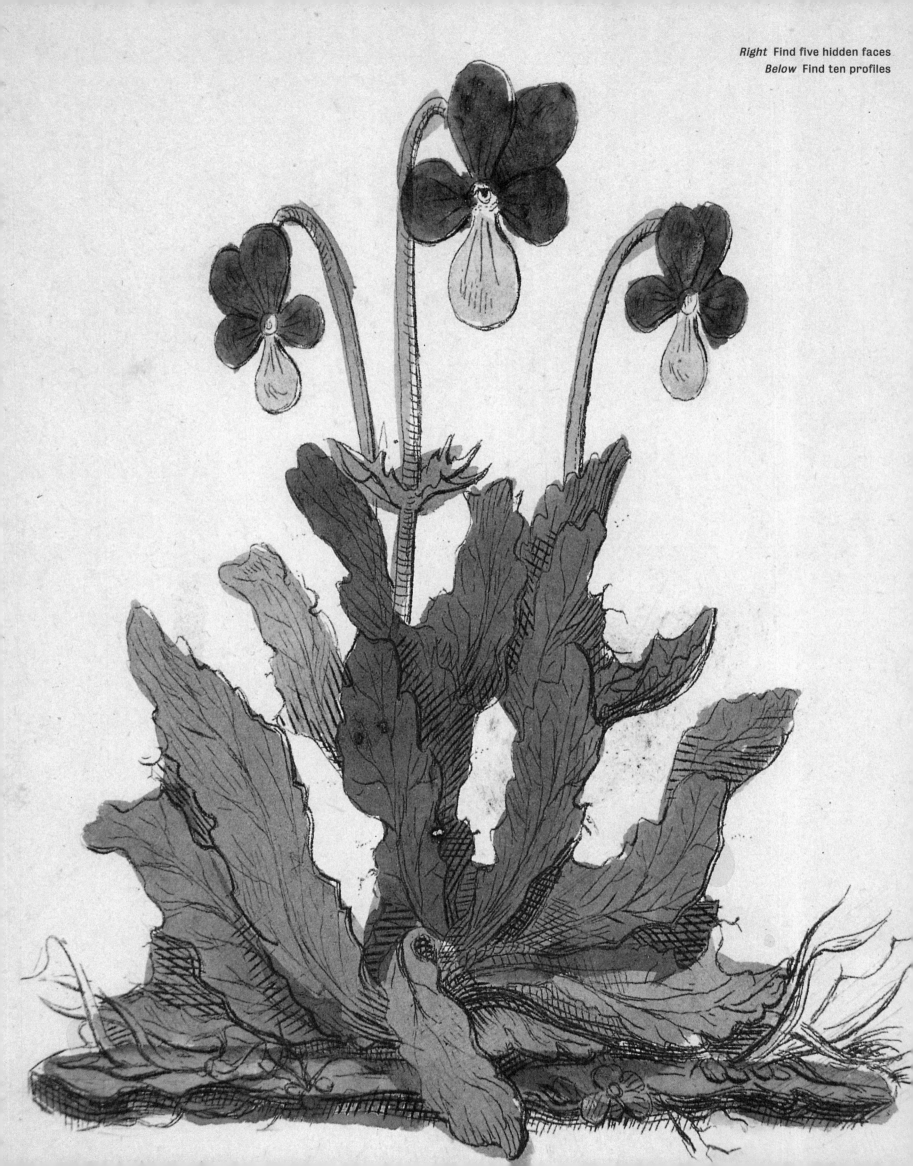

Right Find five hidden faces
Below Find ten profiles

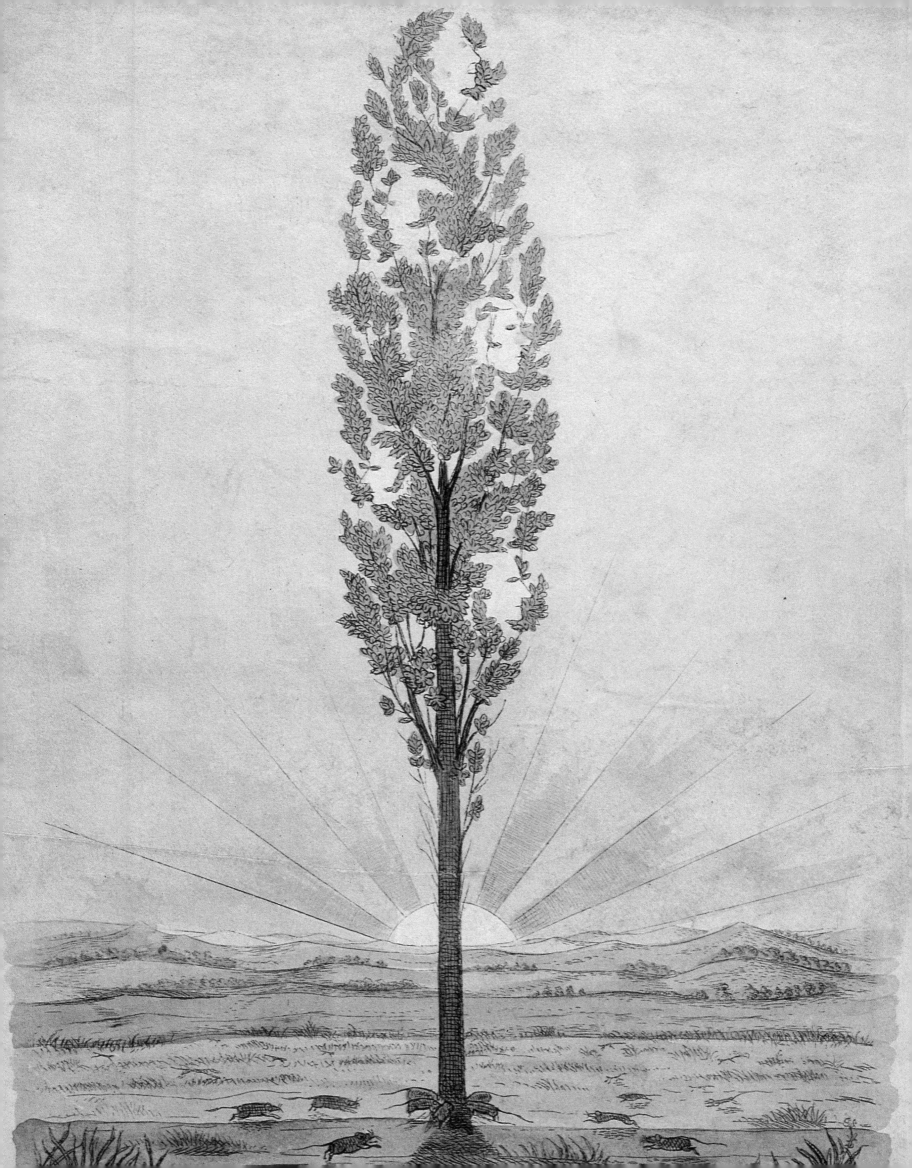

Above Find nine profiles
Right Find Napoleon, his wife and son

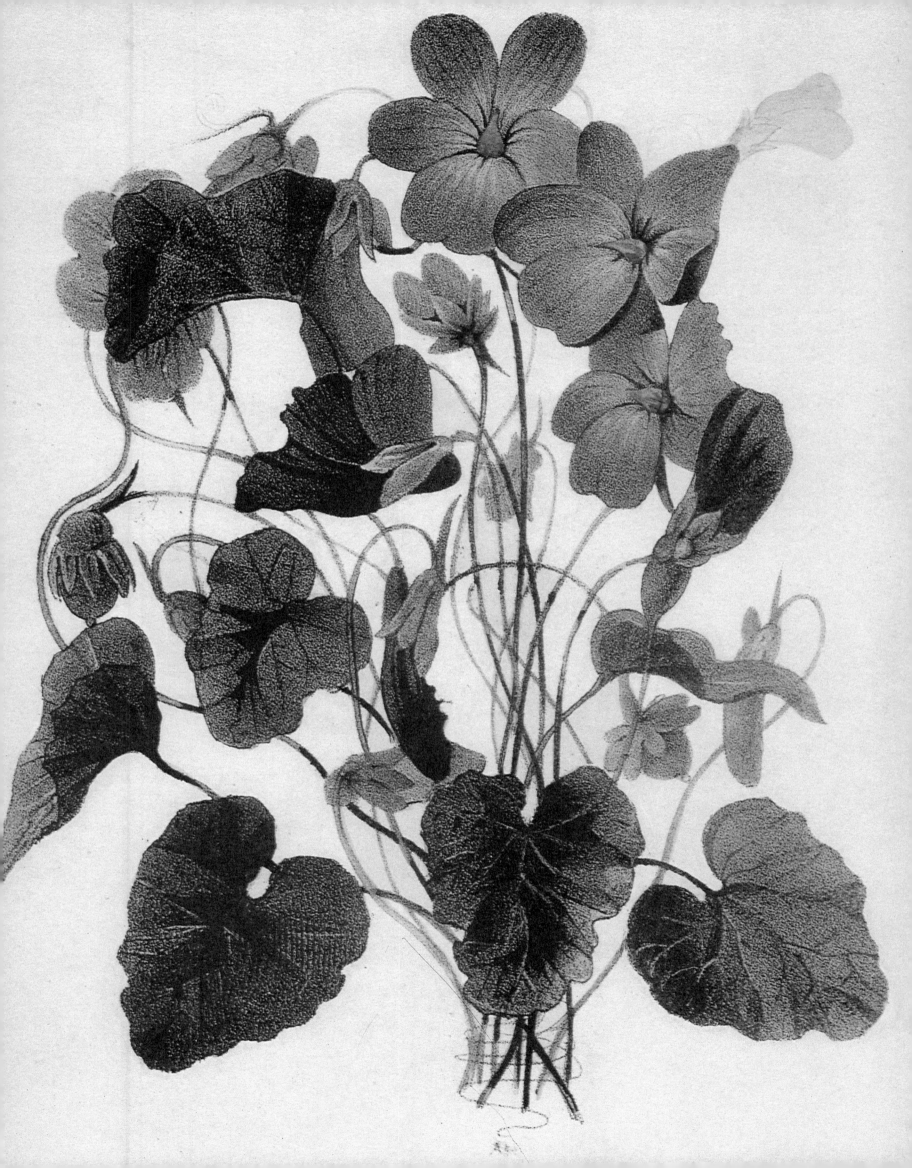

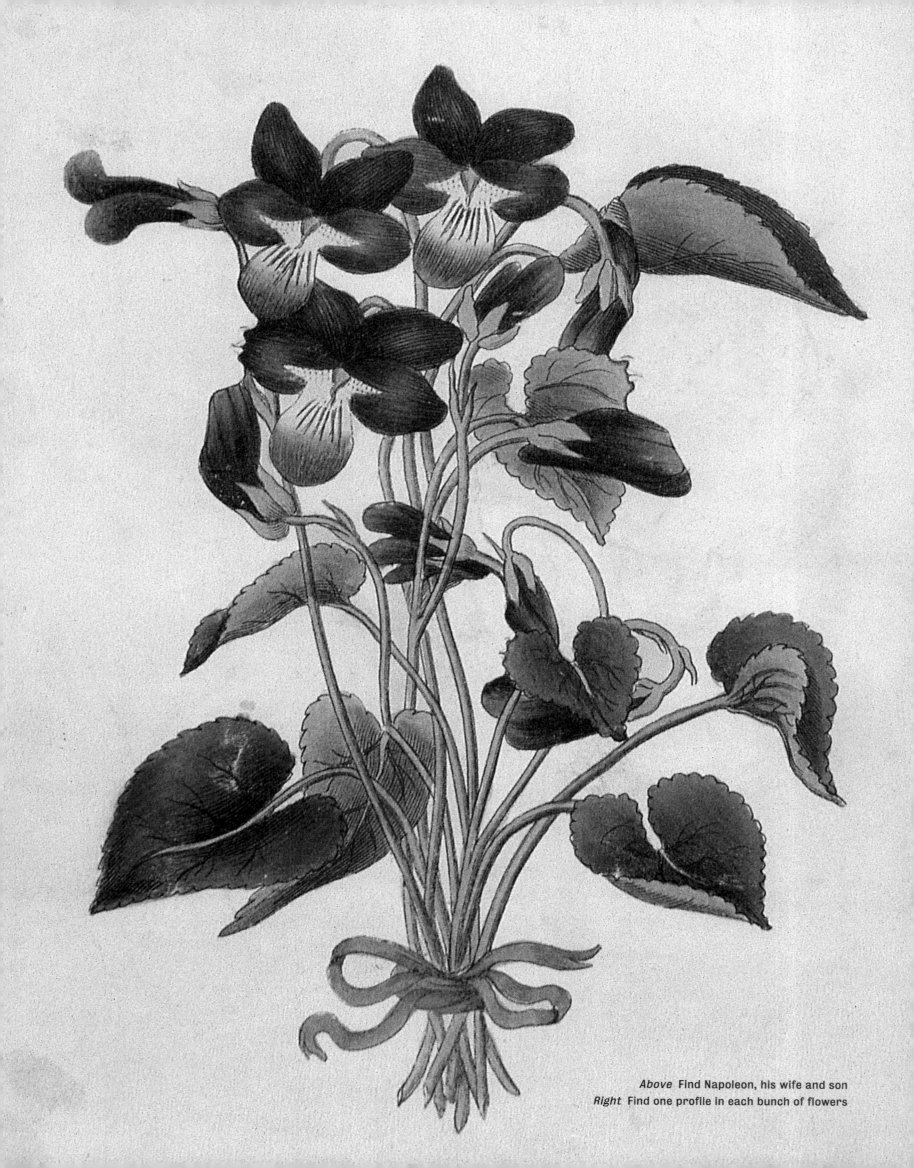

Above Find Napoleon, his wife and son
Right Find one profile in each bunch of flowers

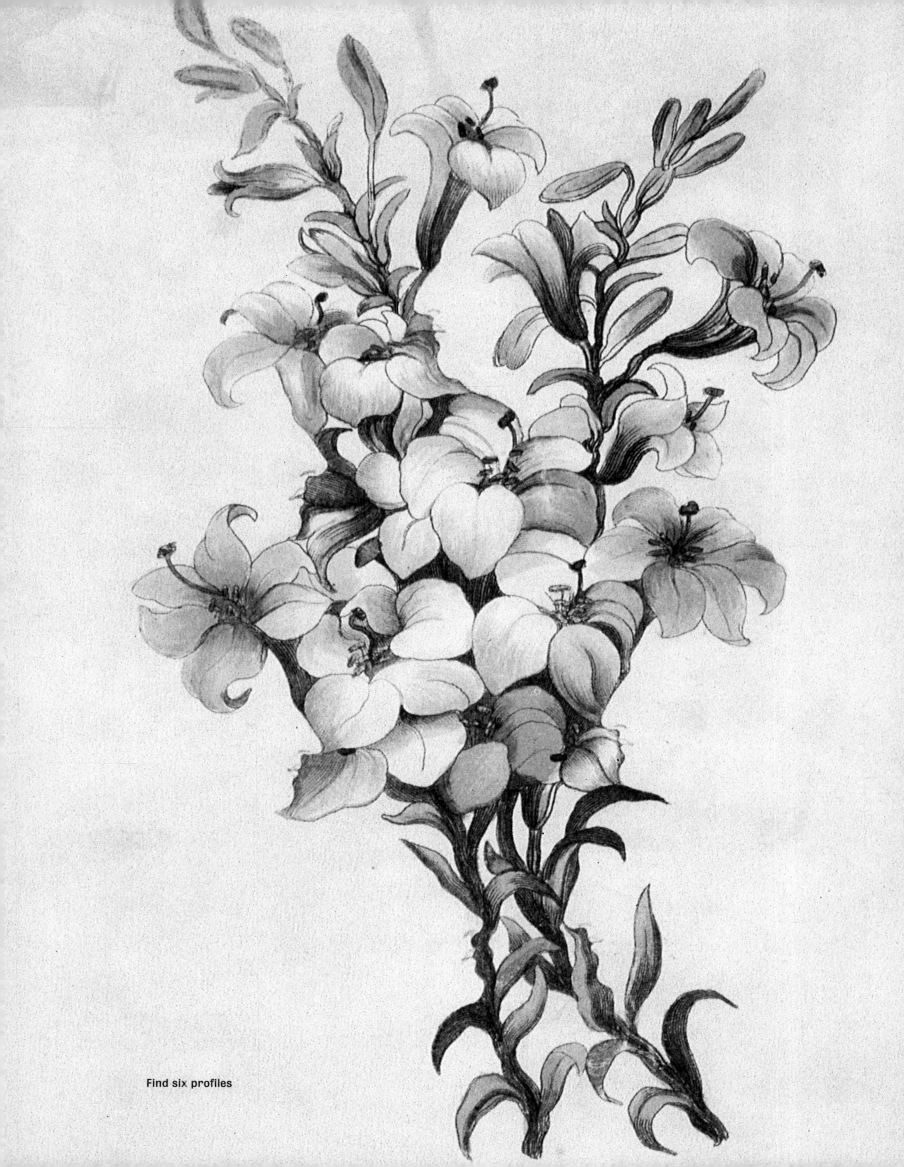

Find six profiles

7

TRANSFORMATION
CARDS

TRANSFORMATION
CARDS

The very idea of transforming playing cards into surprising and unexpected images is comically perverse, though its effectiveness depends, paradoxically, upon our familiarity with the conventional arrangements of the pips (as the individual motifs for hearts, diamonds, spades and clubs are known) and with the colours of the suits, red and black. For instant recognisability is the essence of the playing card face. In card games decisions of choice, discard, arrangement, play, disguise, disclosure etc. must be made at speed and under pressure. Nothing should distract attention from a card's suit and value. Dealt a hand we quickly sort it according to the play required by the rules of the game, and the design of both pip (ace to ten) and face cards (king, queen, knave) has also been developed to facilitate this manoeuvre, making possible a reading of the hand when arranged as a fan with only corners showing. The cards are designed to be immediately recognised either way up.

The wit or humour (or both) of a given set of transformations is of that kind created by a strict constraint. This demands the ingenious creation of pictures containing the pips as convincing elements without disturbing their usual configuration within the rectangle. Success depends upon surprise: the surprise, for example, of a visual pun (the diamond becomes the top of a box carried at an angle or the wing of a workman's hod); or the surprise of a narrative discovered in the ordered circumstance of the pips (a serenade to a young woman in the three of spades, the huckster selling watches in the two of diamonds, the tennis match in the six of clubs).

The earliest transformations were published in Germany in 1801 as illustrations for a version of Samuel Butler's satirical poem *Hudibras*. These, like others produced in Germany and Poland the following year, merely exploited the device without extending it to the entire pack of cards. The first ever complete pack, 'Metastasis', was produced in England in 1803 by the caricaturist John Nixon and was published over a number of years in sheet form. Since then over 70 packs have been published in Europe and the United States, variously satiric, comic, romantic, erotic, commemorative, or simply illustrative of stories or nursery rhymes. Most are complete, though some do not transform the face cards.

The black-and-white cards which follow were designed by Countess Charlotta von Jennison-Walworth and published in Germany by Johann C. Cotta in 1805. The coloured pack, Vanity Fair', was produced in the USA in 1895.

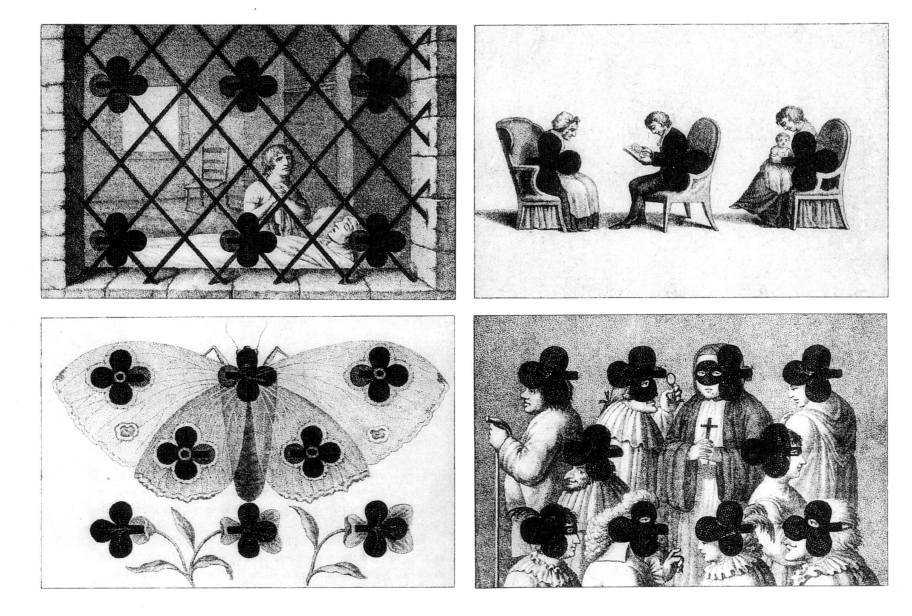

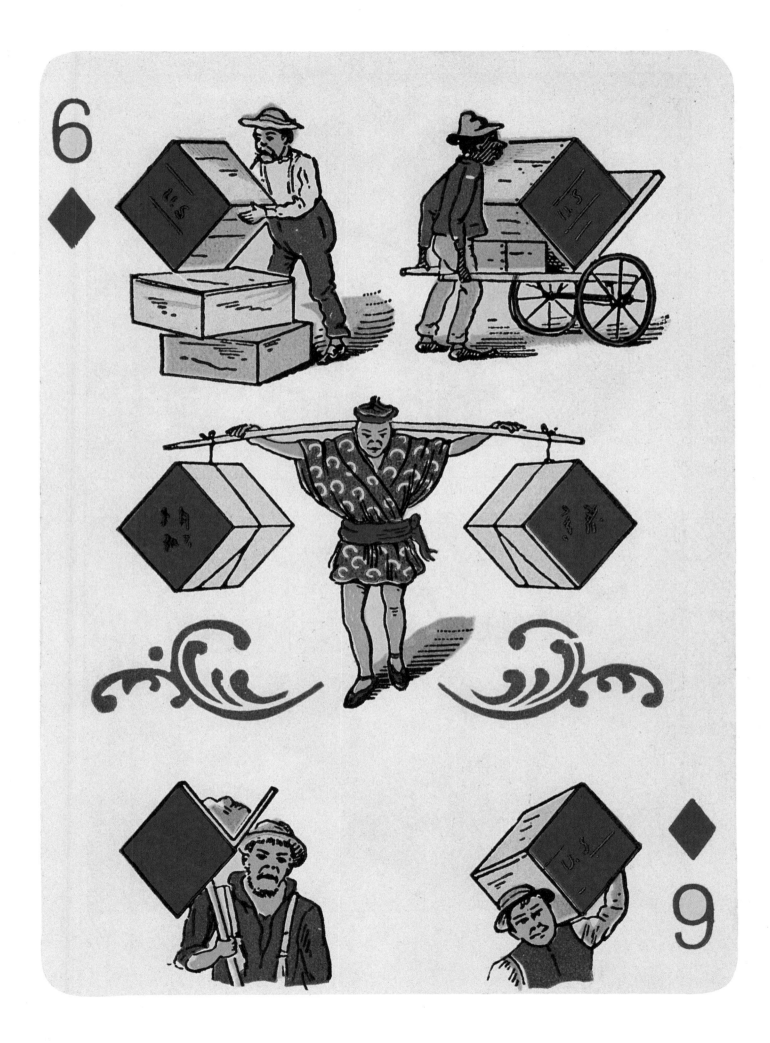

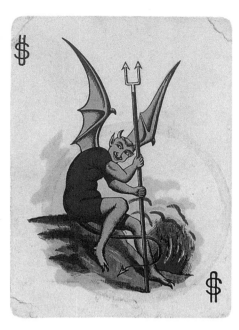

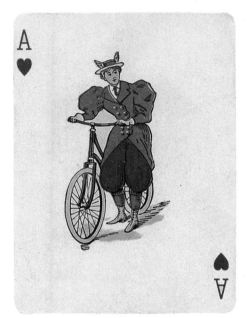

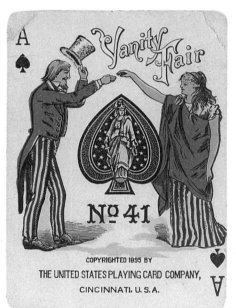

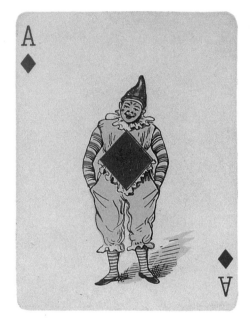

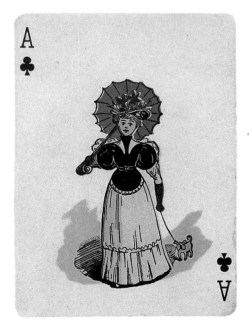

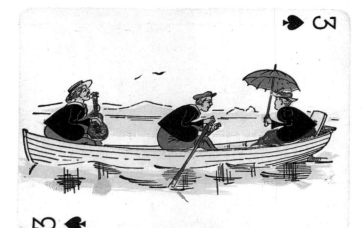

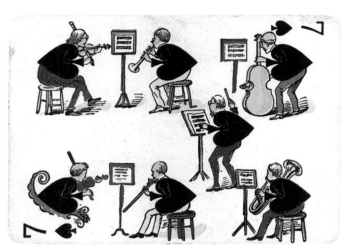

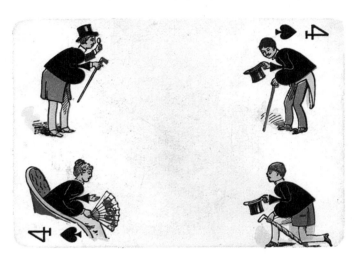

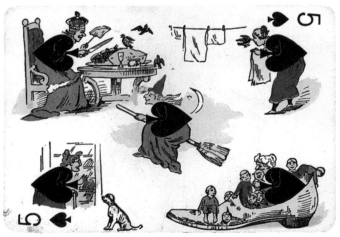

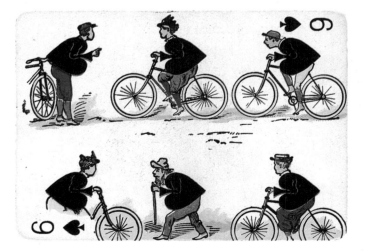

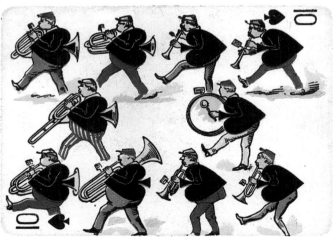

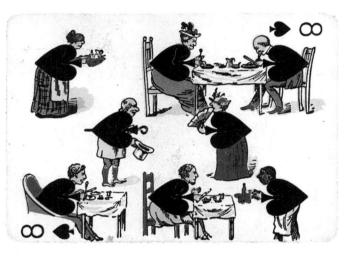

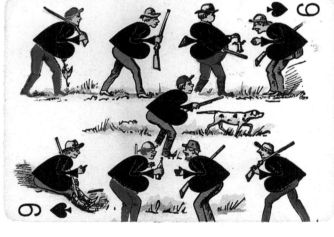

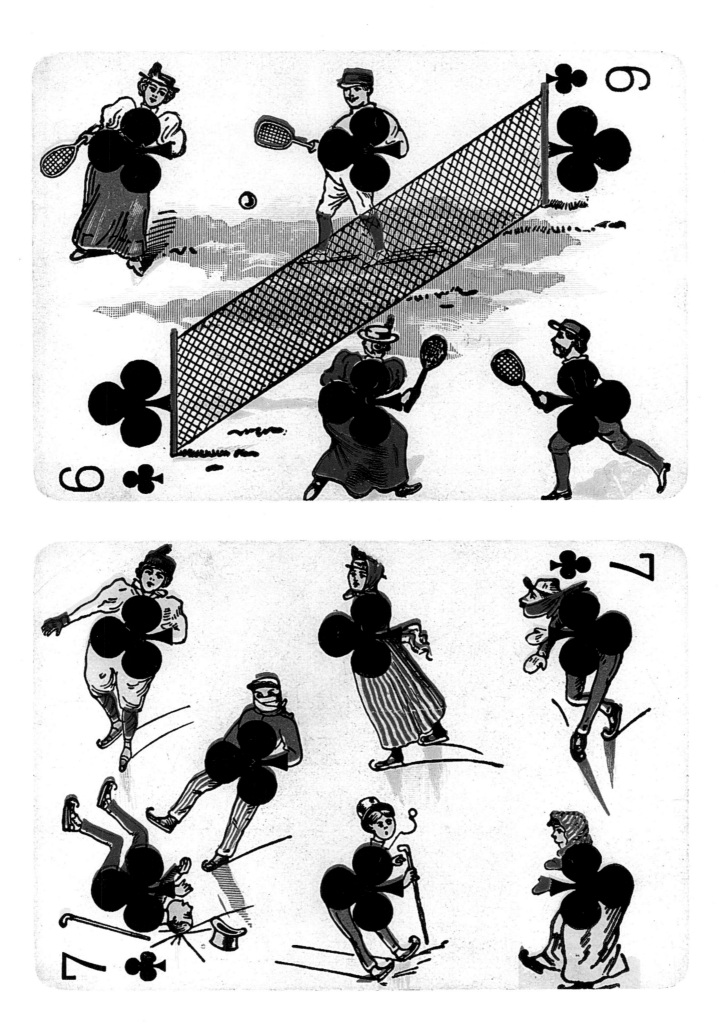

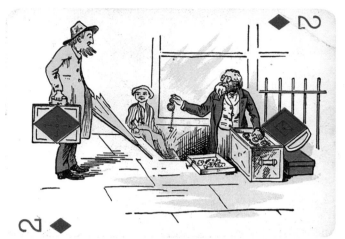

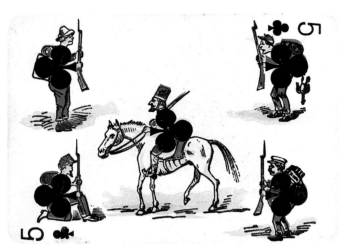

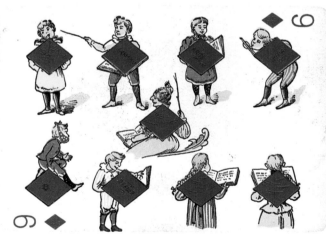

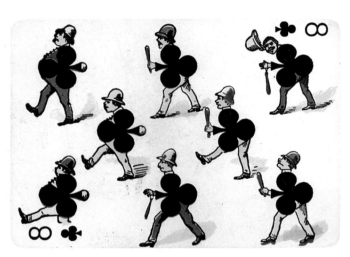

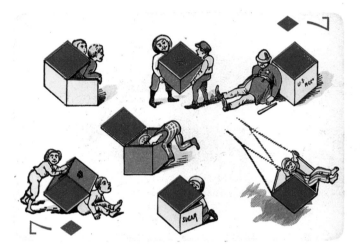

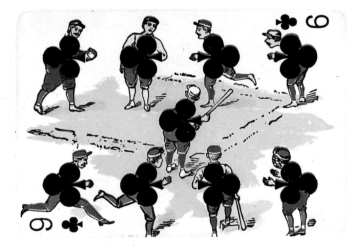

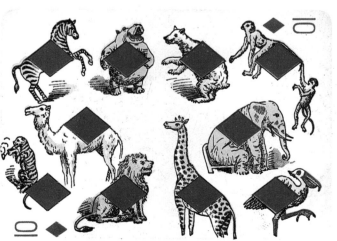

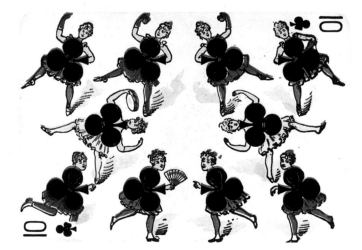

8

REBUSES

8

REBUSES

The term *rebus* comes from the Latin phrase *non verbis sed rebus*, meaning 'not by words but by things'. A rebus is a puzzle in which letters, syllables, whole words, names and phrases in a sentence are replaced 'by things' – visual images, symbols, or arrangements of figures or letters – in such a way as to suggest the missing verbal elements. Sometimes these 'things' are themselves verbal puns on the substituted elements.

There is something very pleasing to the mind in the substitution of an image of something for the abstract verbal symbol. (We like it that the lips form the letter O in a physical form, something that can be seen even as the letter is heard.) Why? Because we carry into maturity a primitive (and fallacious) notion that all language begins in nouns, which are words for *things*. Words, as we know, are notoriously unstable and nebulous, their meanings un-fixed and un-fixable. How simple it would be if only concrete images of things could replace words and short-circuit the complicated processes of memory and association!

Some poetry attempts such simplicity:

> so much depends
> upon
>
> a red wheel
> barrow
>
> glazed with rain
> water
>
> beside the white
> chickens

The famous watchword of William Carlos Williams, who wrote this poem, was 'No ideas but in things!'

The most thorough-going attempt to substitute things for words was undertaken in the school of languages at the Grand Academy of Lagado, the metropolis of the island of Balnibarbi, where the first project 'was to shorten discourse by cutting polysyllables into one, and leaving out verbs and participles, because in reality all things imaginable are but nouns'. Lemuel Gulliver, who visited the Academy during his travels into several remote nations of the world, went on to describe the other main project of the professors there as 'a scheme for entirely abolishing all words whatsoever . . . since all are only names for things, it would be more convenient for all men to carry about them such things as were necessary to express the particular business they were to discourse on.' *Rebus* communication had

this inconvenience: 'that if a man's business be very great, and of various kinds, he must be obliged in proportion to carry a greater bundle of things on his back, unless he can afford one or two strong servants to attend him.' Gulliver often observed these academics 'almost sinking under the weight of their packs . . . [and] who when they met in the streets, would lay down their loads, open their sacks, and hold conversation for an hour together; then put up their implements, help each other to resume their burthens, and take their leave'. It is not surprising that the women of Balnibarbi, 'in conjunction with the vulgar and illiterate', threatened rebellion if they were not 'allowed the liberty to speak with their tongues, after the manner of their ancestors'.

Though it seems strange that no great poet has been tempted to use the device of the rebus proper, a number of great modern artists, Duchamp, Picabia, Ernst, Schwitters, Magritte and Breton among them, have used objects and images in conjunction with words or in the place of words to create the syntactics of a visual poetry. (It is syntax – the articulation of the relations between things – that defines the rebus.) It seems odd to think of the Dadaists and Surrealists as the true successors of the persistent pedants of Lagado. ('If the fool would persist in his folly he would become wise.' – William Blake)

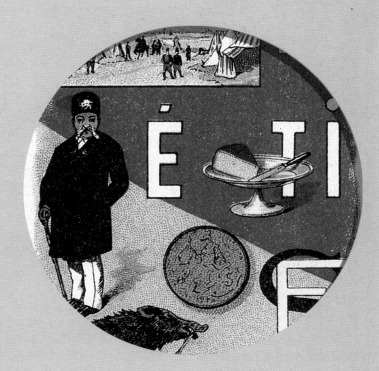

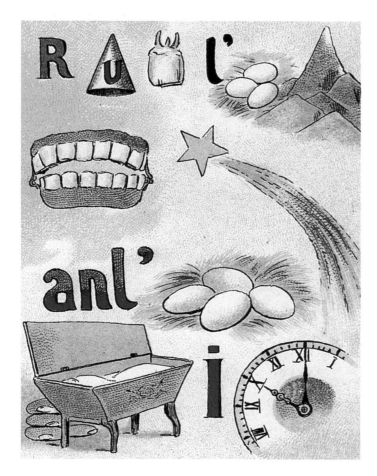

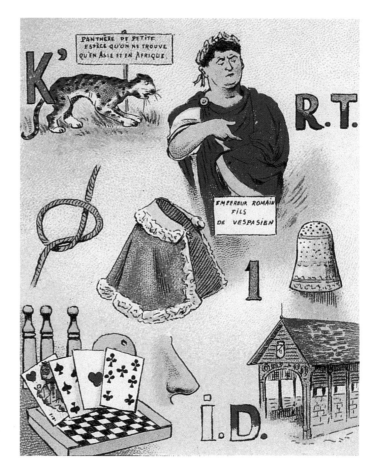

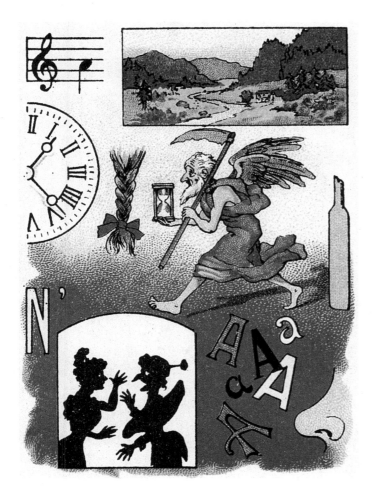

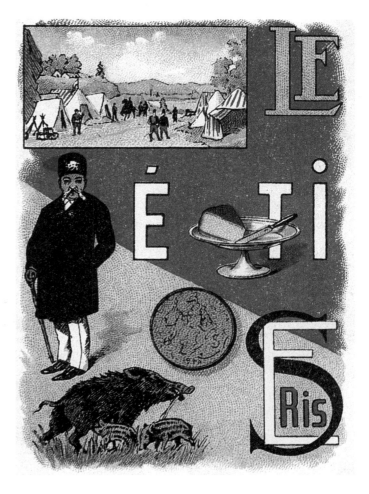

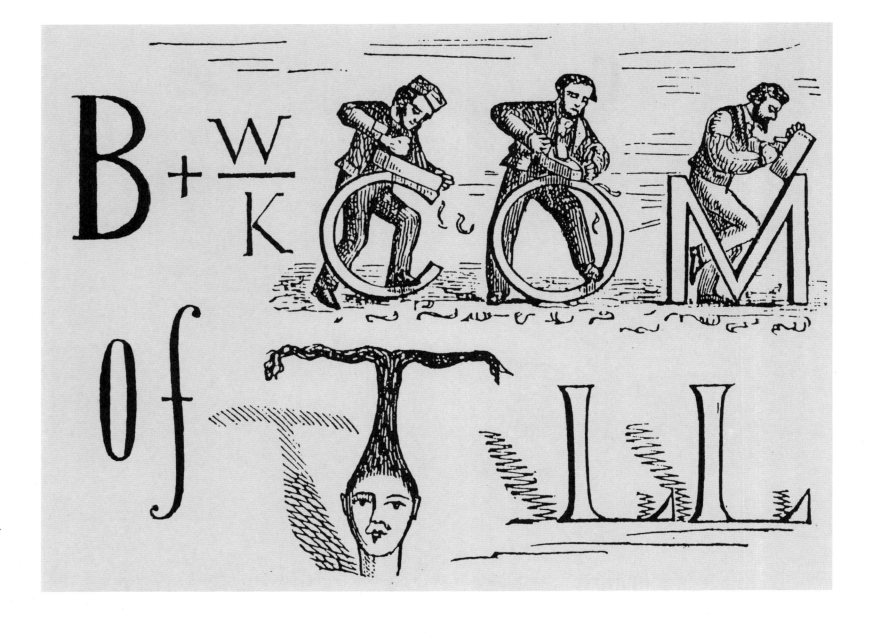

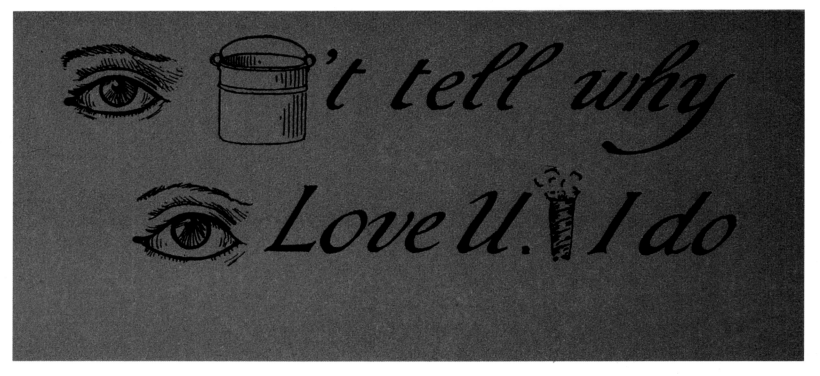

Solutions to the rebuses on pages 86, 87 and 88 can be found on page 101

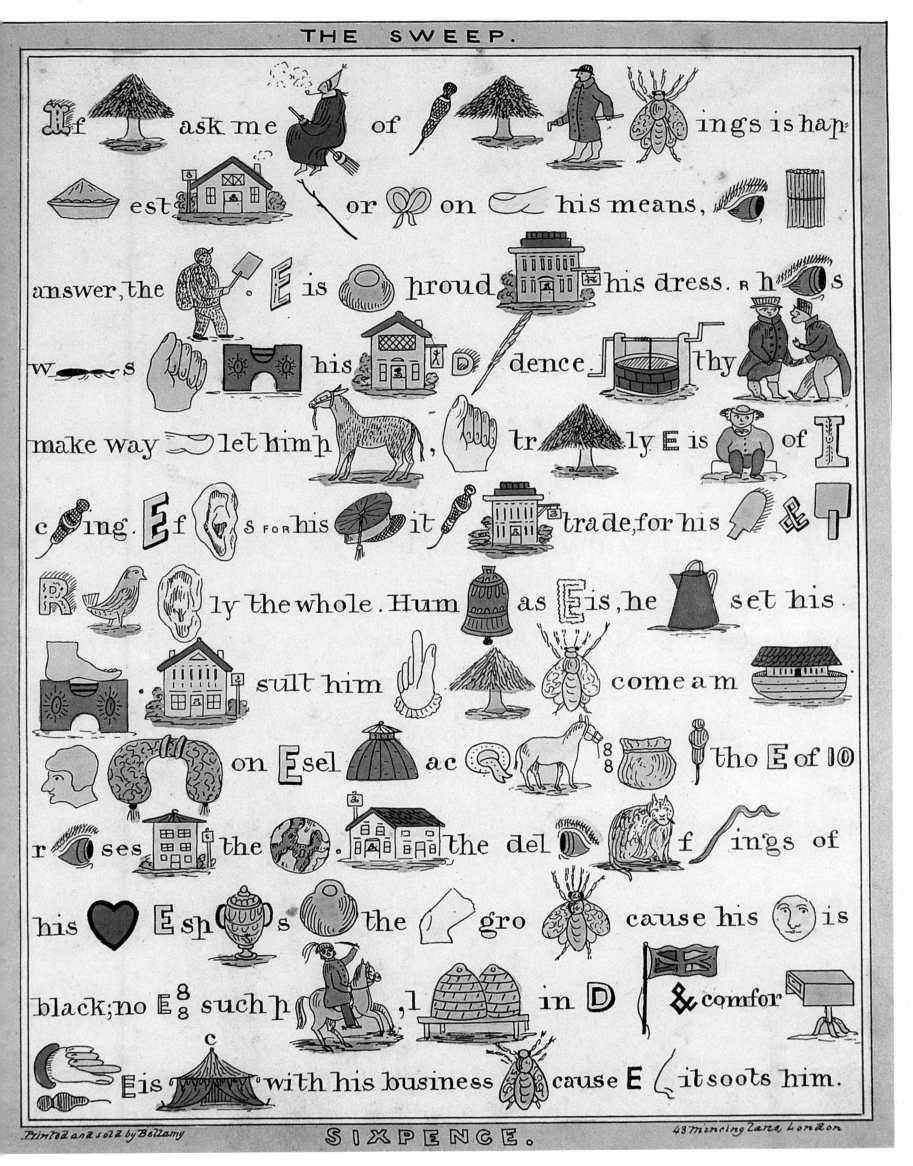

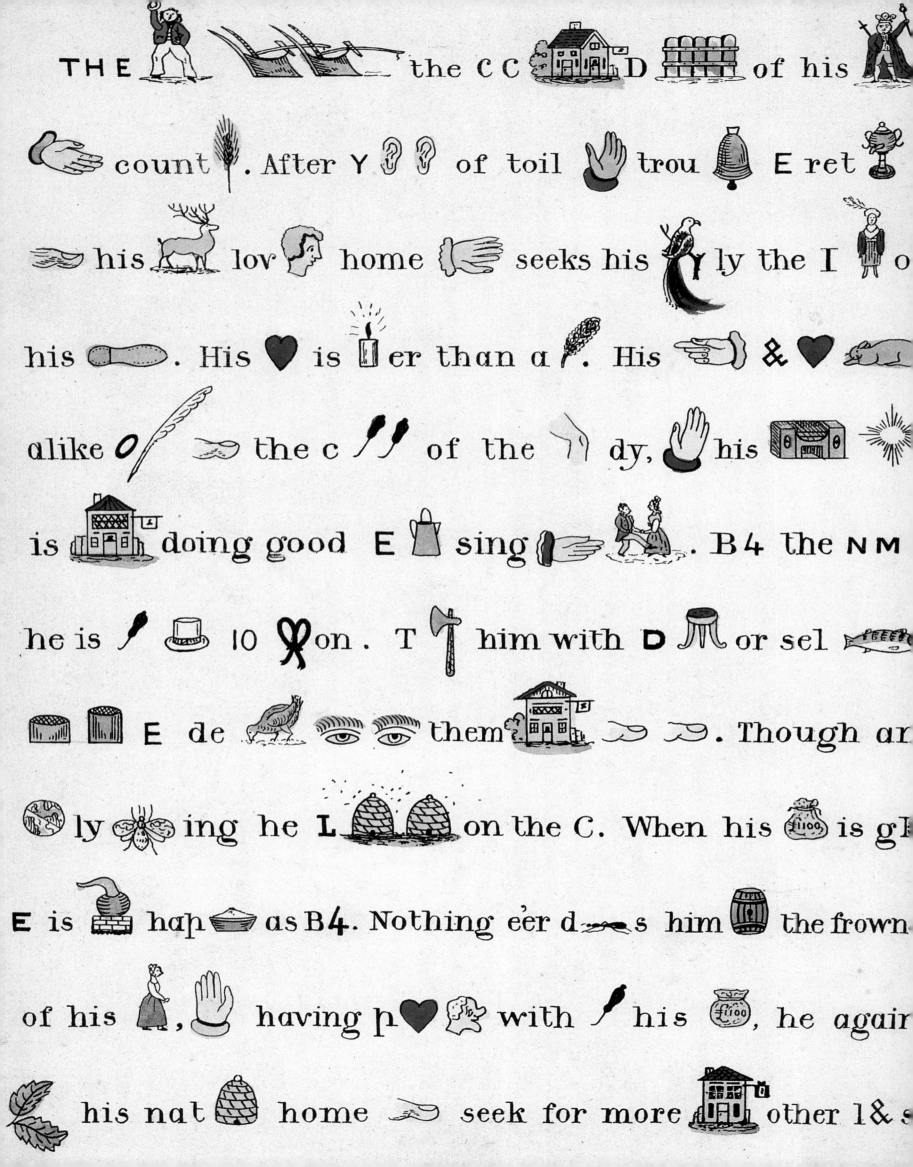

9
DEVINETTES

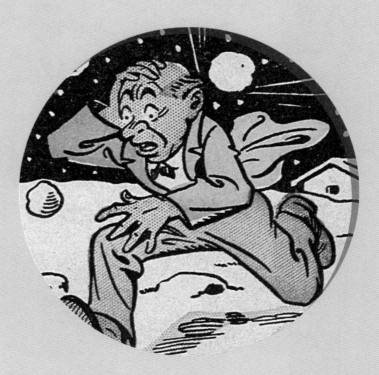

From the Revolutionary period until the early years of the twentieth century the small town of Épinal in the Vosges region of eastern France was famous for its popular printed imagery. The Vosges had long been a centre of paper making, and fine paper and card had been manufactured at Épinal since the early 1600s. The extraordinary story of *l'images d'Épinal* began with commercial printing there of woodblock engravings of decorated and coloured paper clock-faces and playing cards, and took off when the printer Jean-Charles Pellerin realised that there was in the new France a market for cheap and accessible historical and heroic national prints, centred on the cult of Napoleon, and beyond that for religious and legendary images with a universal appeal. Pellerin later introduced educational prints and games, toy theatres and cut-out figures, encyclopaedic alphabets, histories and natural histories. These were printed as single sheets or gathered into albums. Through the nineteenth century Pellerin's factory made thousands of these popular publications and disseminated them throughout Europe and the Americas. For the first fifty years or so they continued to be printed from wood engravings, but after a period of overlap between the 1850s and 1860s lithography became the principal medium. The quality of lithographic reproduction was at first very high, producing images as fine as those of the wood engravings, but it later deteriorated, and in the years leading up to the First World War the drawing had also become crude and graceless. The prints of this later period, from which this selection is made, nevertheless have a rough charm of their own. During this period a favourite category of prints, often published in album form, were the so-called *devinettes*. These were picture puzzles, usually of the 'hidden image' kind, and mostly aimed at the juvenile market. The word itself derives from *deviner*, meaning 'to work out', or 'to discover', which survives in English in the term 'water diviner'.

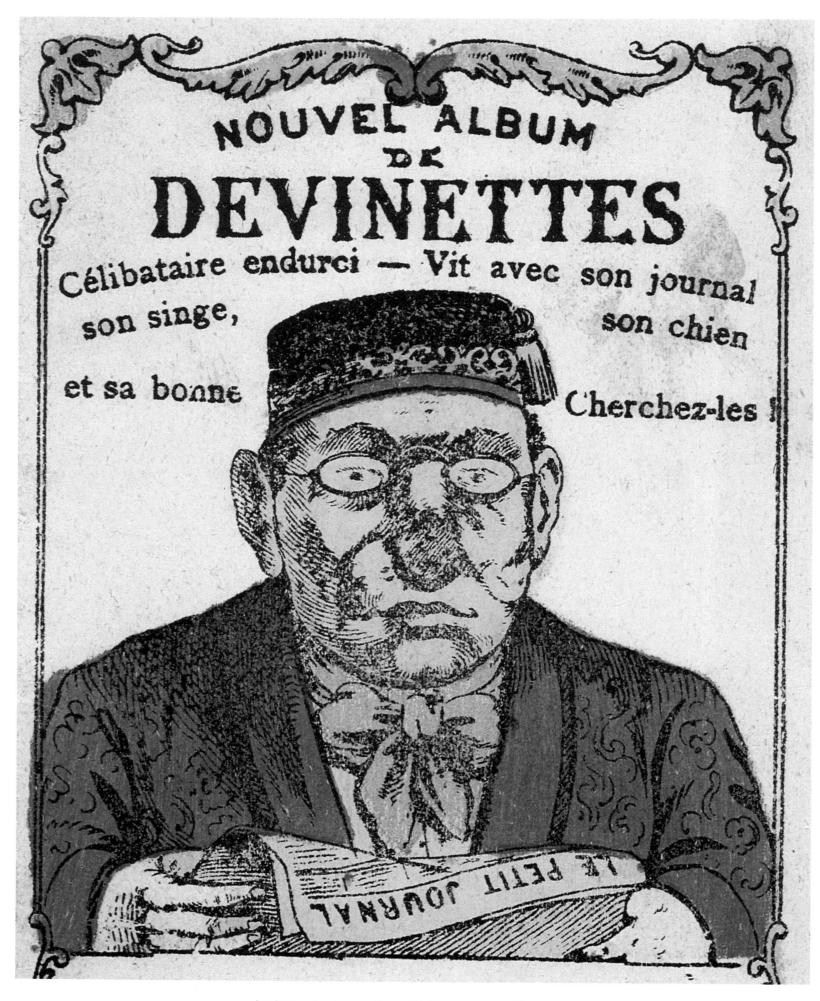

Confirmed bachelor – lives with his newspaper, his monkey,
his dog and his maid. See if you can find them.

Where is the future son-in-law?

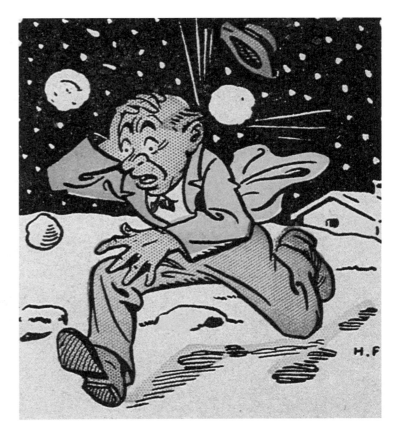

Where is the rascal who's throwing snowballs?

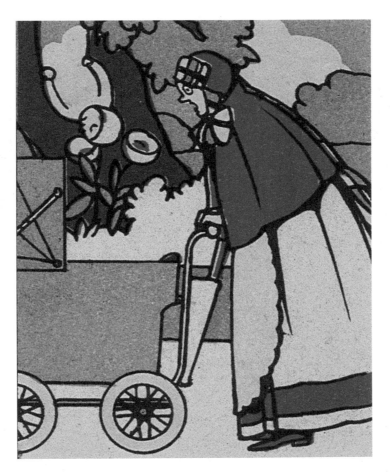

My God! What have I done with baby?

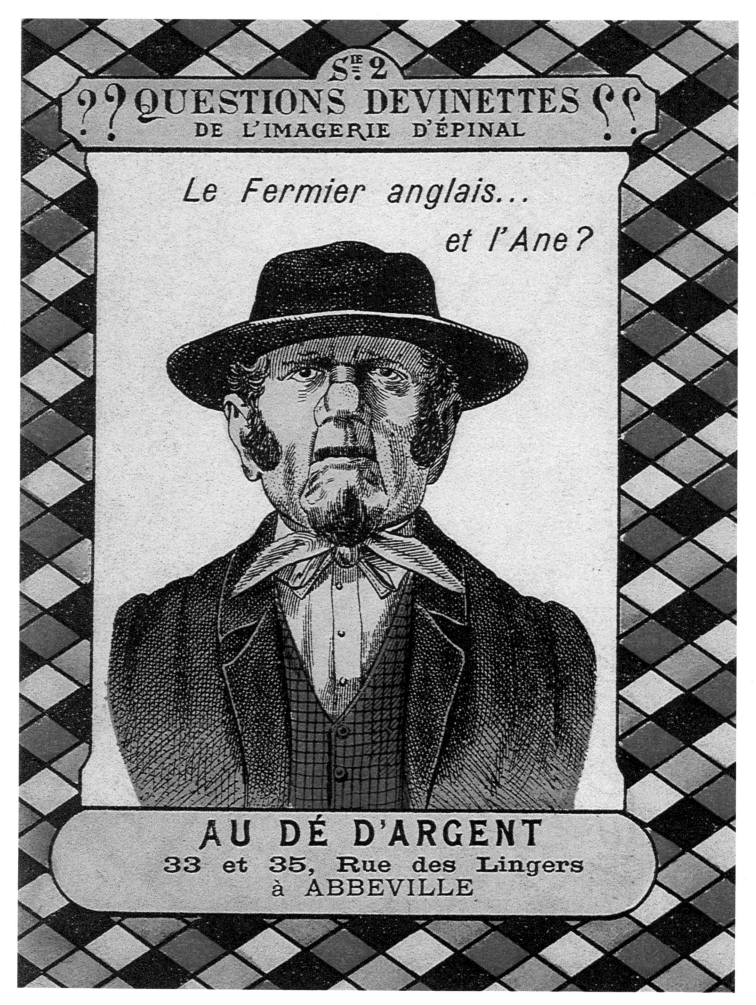

The English farmer . . . and the donkey?

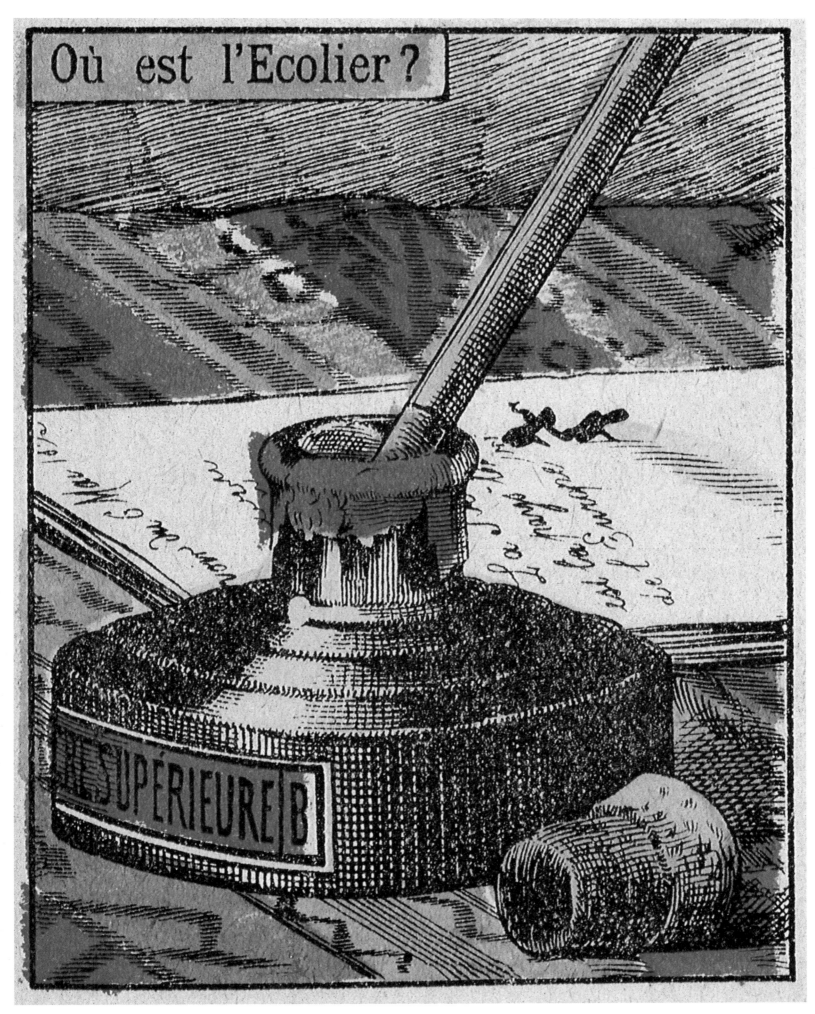

Where is the student?

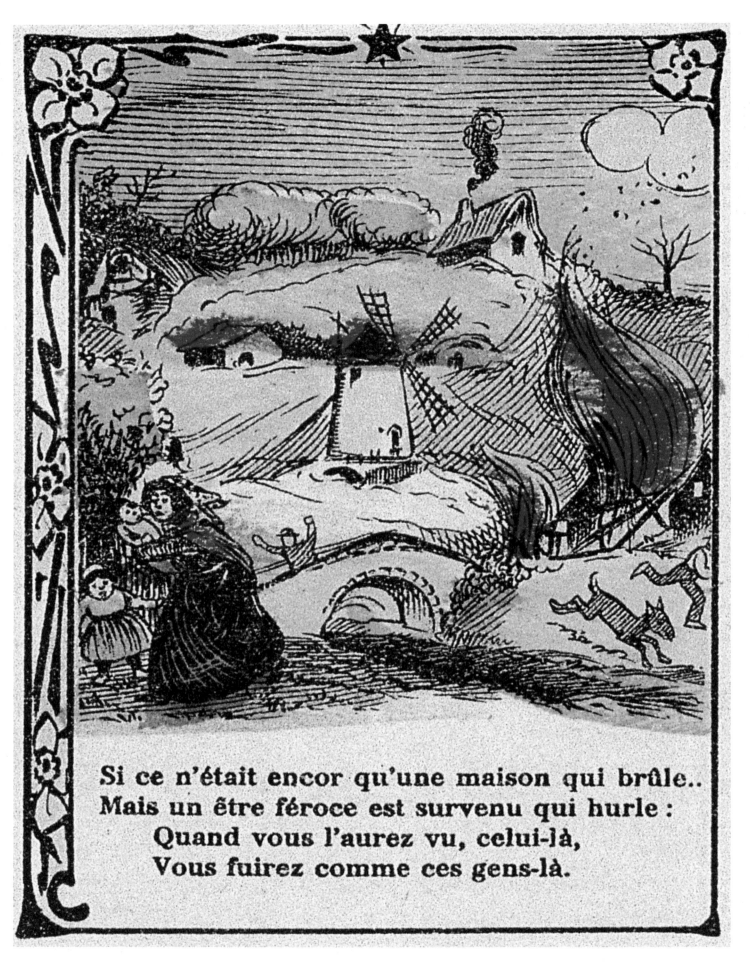

Si ce n'était encor qu'une maison qui brûle..
Mais un être féroce est survenu qui hurle :
Quand vous l'aurez vu, celui-là,
Vous fuirez comme ces gens-là.

If it was only a house burning . . .
But a ferocious, howling creature has appeared.
Catch sight of it, and
Like these people, you'll want to run for your life.

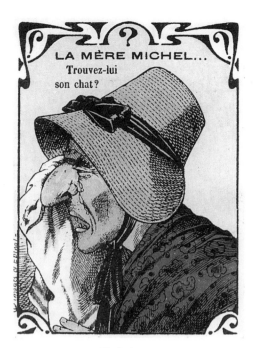

Find the cat

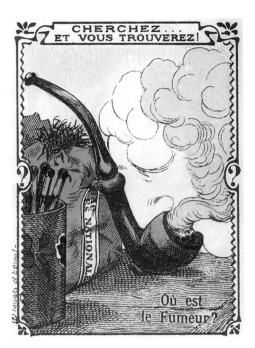

Find the smoker

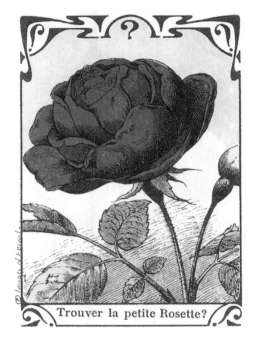

Find the small rosette

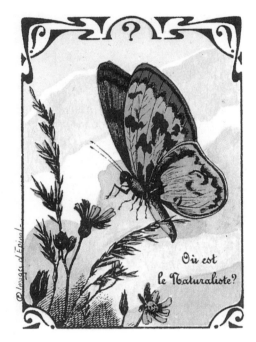

Find the naturalist

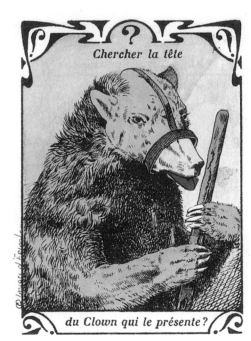

Find the clown's head

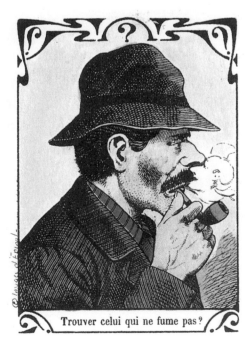

Find the non-smoker

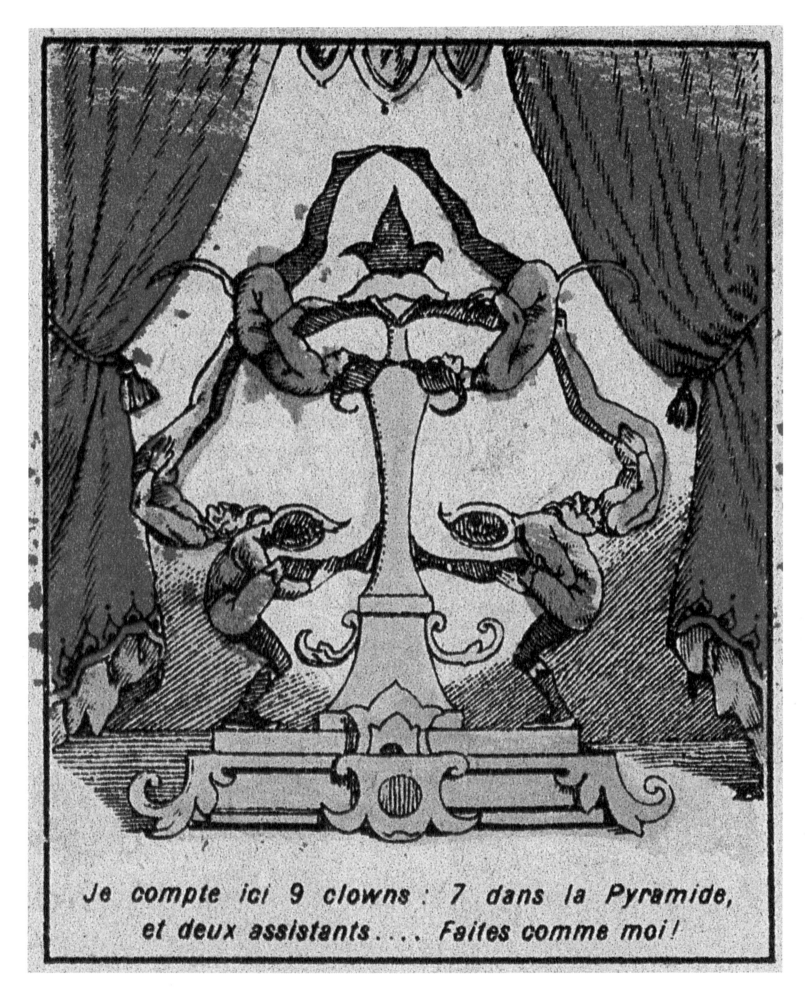

Je compte ici 9 clowns : 7 dans la Pyramide, et deux assistants.... Faites comme moi!

Find nine clowns

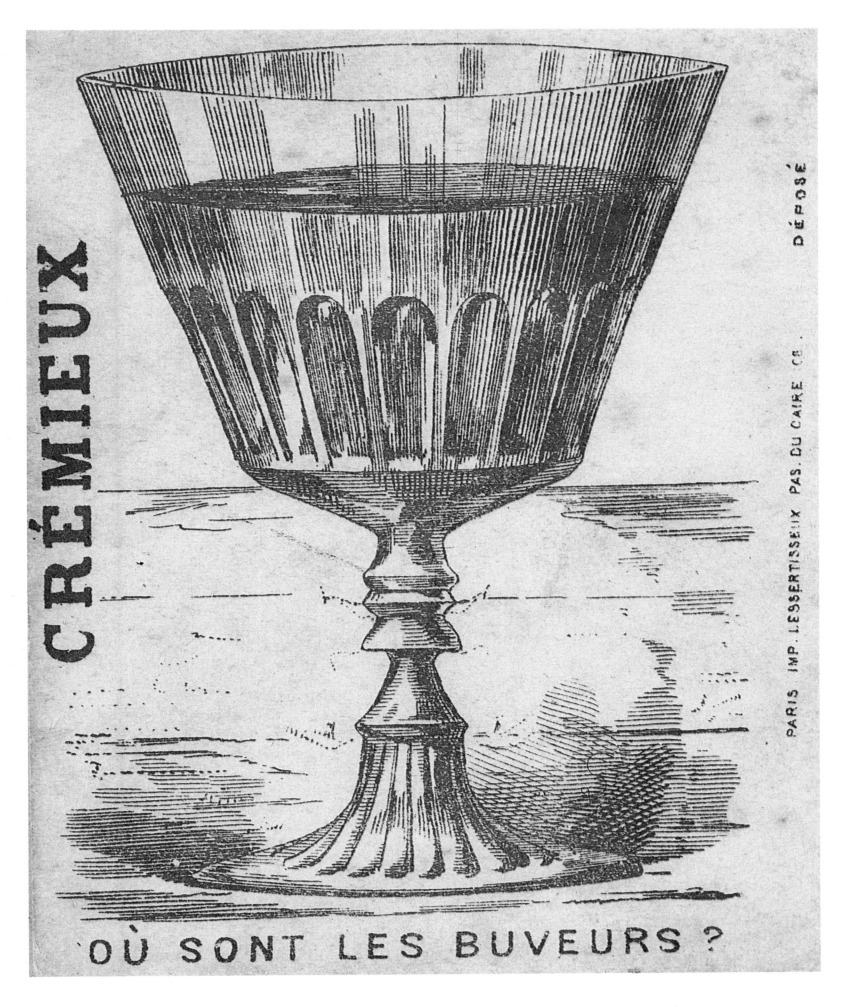

Where are the drinkers?

NOTES/SOURCES/SOLUTIONS/CREDITS

In many cases very little is known about the sources and authorship of the visual materials here compiled. Most of the images have come from the remarkable collections of popular ephemera of James Dalgety and Edward Hordern. The editors are especially indebted to these experts for information, and to the staff of the Bodleian Library, Oxford, for help in identifying materials.

iii Postcard, USA, 1905, 'Are you up to it?'
iv Carte de visite, UK, 1870
x Postcard, UK, 1910, 'The Kiss and its Consequences'

HIDDEN IMAGES

4 Popular print, UK, 1831 (pub. R. Ackermann). Napoleon died on the island of St. Helena in 1821. For years afterwards popular prints were produced depicting his ghost at his grave.
5 Popular print, USA, 1878 (pub. Currier and Ives), 'Washington at his Tomb'
6 Popular print, UK, c.1830 (pub. R. Ackermann), 'The Spirit of Byron'
7 Popular print, UK, 1838 (pub. unknown), 'Scene near Windsor'
8 Postcard, UK, 1913 (pub. in *Pictorial Comedy* series; illus. by J.M. Flagg)
9 Magazine illustration, France, 1918 (illus. for *Fantasio* by A. Vallée)
10 Postcards, top L: France, c.1900, Diàbolo; top R: France, 1905 'L'Amour de Pierrot', lower L: UK, 1900, 'Life and Death', lower R: UK, 1900, 'Mephisto'
11 Top: advertising card, USA, 1879. One of a series of four advertising patent medicines. The picture contains 75 hidden people, animals, objects and letters. Bottom: postcard, Germany, early 20c.
12 Give-away card, France, c.1880

MULTIPLE FIGURES

16 Copies of paintings in the City Palace, Jaipur, Rajasthan, India, 1710
17 Woodblock print, Japan, c.1850 'Cat and kittens'
18 Painting, Jaipur, Rajasthan, India, c.1820
19 L: Painting, Jaipur, Rajasthan, India, early 20c.
R: Watercolour, Jaipur, Rajasthan, India, c.1800
20 Woodblock prints, Japan, 1860s
21 Woodblock print, Japan, c.1855
22 Matchbox labels, Japan, c.1900
23 Woodblock print, Japan, c.1860
24 Woodblock print, Japan, c.1850

POLITICS

28 Woodblock print, UK, c.1810 (pub. R. Ackermann). Anti-Napoleon broadsheet; according to the original caption, the hat represents the 'maimed and crouching French eagle', the face is composed of 'the victims of his folly and ambition.'
29 Postcard, France, c.1905. Archimboldesque portrait of Napoleon
30-31 Map drawn by Kisaburo Ohara, origin unknown, 1904
32 Postcard, France, 1906. Russian Imperial family in year of suppressed revolution in Russia
33 Popular print, Frankfurt, Germany, 1849
34 Cover of *Judge* magazine, US, May 1894. Anti-Tariff Bill propaganda
35 Popular lithograph print, UK, early 20c. (date unknown), 'The unspeakable Turk – an arch and fowl mystery'
36 Cover of *Match* magazine, France, 12 October 1939, by Salvador Dali

UPSIDE-DOWNS

40 Top L: matchbox label, Japan, 1935; top R: matchbox label, India, 1948; lower L: pamphlet cover, India, 1980s; lower R: woodblock print, Japan, 1847
41 Top L: matchbox label, India, 1927; top R: matchbox label, Spain, 1875; lower L: matchbox label, Italy, 1870; lower R: matchbox label, Mexico, 1915
42 Matchbox label, Italy, 1870
43 Woodblock print, Japan, c.1830
44 Matchbox label, Spain, 1865
45 Woodblock print, Japan, c.1850
46 Illustrations from Peter Newell's *Topsy-Turvies* (Century Co., USA, 1893)
47 Sheet music novelty: 'The Way of the World', c.1900
48 Cover of pamphlet, Italy, 1946. Anti-Socialist/Communist Popular Front propaganda

OPTICAL ILLUSIONS

52 Cigarette card, UK, 1926, from 'Optical Illusions' series (pub. Major Drapkin and Co.)
53 Advertising cards, France, 1920s, for Era margarine
54 Advertisement, UK, 1889. Anamorphic lettering reads: 'Cleaver's soap is the best'
55 Postcard, UK, 1880, 'A calligraphic mystery': 'one touch of nature makes the whole world kin'
56 Cigarette cards, UK, 1927, from 'Optical Illusions' (pub. Ogden's Tobacco Co.)
57 Cigarette cards, UK, 1926, from 'Optical Illusions' series (pub. Major Drapkin and Co.)
58 Page from J.H. Brown's *Spectropia or Surprising Spectral Illusions Showing Ghosts Everywhere and of Any Colour* (Griffith and Farran, UK, 1866). These illusions exploit the phenomenon of persistence of vision. This is the after-image effect by which the eye produces, against a plain background, a shadowy version of a simple image at which it has stared for some time.

HIDDEN PROFILES

62 Coloured engraving, UK, 1830s (pub. R. Gilbert). 'In the drawing may be traced the following profiles, taken from

the most approved likenesses: Sir Walter Scott, Queen Adelaide, Duke of Cumberland, Lord Brougham, Napoleon Buonaparte, King William, Duke of Wellington, Princess Victoria.'

63 Coloured engraving, France, early 19c. 'Les Fleurs réalisent nos espérances' ('Flowers which make our hopes come true')

64 Engraved broadsheet, UK, 1815 (pub. G. Smeeton). Contains profiles of the Prince Regent, Duke of Wellington, Emperor of Austria, King of France, Emperor of Russia, Prince Talleyrand, King of Prussia, Prince Swartzenburg, Blücher and Platoff

65 Coloured engraving, UK, 1831 (pub. R. Jay). Text below the engraving reads: 'With a firm, deep Root, to its native soil it clings/And despite Storms or Vermin, it upward springs/Foster'd by Freedom's Race, it stands Alone/Shoots promised fruit, and Hails the Rising Sun/Speeds forth its Gems, the genial warmth to Share/And Boldly trusts its Buds in open Air.' Contains profiles of King William IV, Lord Grey, Lord Brougham, Lord Russell, Lord Durham

66 Coloured engraving, UK, mid 19c. (pub. unknown). Contains profiles of nine members of the Royal Family including Queen Victoria and Prince Albert

67 Coloured engraving, UK, 1815 (pub. unknown). Contains profiles of Napoleon, his wife and son

68 Coloured engraving, France, 1815 (pub. unknown). Pro-Napoleon popular print from an original drawing by Canu, March 1815. Supporters of the exiled Emperor wore bunches of violets as a secret sign of their allegiance, and would toast 'Corporal Violet'

69 Coloured engraving, UK, 1831 (pub. Wm. Darton & Sons). Contains profiles of supporters of the Reform Bill

70 Coloured engraving, France, 1815 (pub. unknown) 'Lilies of France' contains profiles of the French Royal Family

TRANSFORMATION CARDS

74 and 76 Transformation playing cards, Germany, 1805 (pub. Johann C. Cotta). 'Jeanne d'Arc' designed by Charlotta von Jennison-Walworth

75, 77, 78, 79 and 80 Transformation playing cards, USA, 1895 (pub. United States Playing Card Company). The 'Vanity Fair' pack

REBUSES

84 Cover of *Rebus Alphabet Book*, USA, 1880 (McLoughlin Bros. New York)

85 Give-away cards, France, 1900 (pub. Le Chocolat du Plantier). Solutions unknown

86 Top: book illustration, UK, 1860, from *Beeton's Book of Household Amusement* (Ward, Lock & Tyler) 'Bad workmen complain of their tools' Bottom: postcard, USA, c.1910. 'I can't tell why I love you but I do'

87 Popular print, UK, mid 19c. (pub. Bellamy), 'The Sweep'. 'If you ask me which of all human beings is happiest in proportion to his means, I would answer, the sweep. He is not proud in his dress, small are his wants, and great his

independence. Wealthy men make way to let him pass, and truly he is a man of high calling. He fears little for his Capital in trade, for his brush and shovel are nearly the whole. Humble as he is, he can set his foot upon the grate. Insult him and you become a marked person. He seldom accumulates riches, though he often rises in the world. In the delicate feelings of his heart, he spurns not the negro, because his face is black; no, he hates such pride, lives independent and comfortable, and above all he is content with his business, because he knows its suits him.'

88 Popular print, UK, c.1870 (pub. unknown), 'The Sailor'. 'The sailor ploughs the seas in defence of his king and country. After years of toil and trouble, he returns to his dear loved home and seeks his Polly, the idol of his soul. His heart is lighter than a feather. His heart and hand are alike open to the calls of the needy, and his great glory is in doing good. He can sing and dance. Before the enemy he is all attention. Tax him with deceit or selfish measures, he denies them in toto. Though an earthly being he lives on the sea. When his money is gone he is as happy as before. Nothing e'er daunts him but the frowns of his lass, and having parted with his treasures, he again leaves his native home to seek for more in other lands.'

DEVINETTES

92–99 Lithographic puzzle images from Épinal, France, late 19c./early 20c.

NOTES TO TEXTS

Leo Steinberg is quoted from 'The Eye is a Part of the Mind' reprinted from *Partisan Review*, vol. XX no 2, 1953, in *Reflections on Art*, ed. Susanne K. Langer (The John Hopkins Press, 1961). E.H. Gombrich's essay 'On Physiognomic Perception' first appeared in *The Visual Arts Today*, ed. George Kepes (Cambridge, Mass., 1960) and was reprinted in *Meditations on a Hobby Horse* (Phaidon, London, 1963). For information on transformation cards see *Transformation Playing Cards* by Albert Field (U.S. Games Systems, Stamford, Connecticut, 1987); and on the popular imagery of Épinal see *Images d'Épinal* by Denis Martin with Bernard Huin (Musée du Québec, 1995).

THE EDITORS

JULIAN ROTHENSTEIN has worked as a designer and publisher for over 25 years. He started Redstone Press in 1986 with a series of boxed books and has subsequently designed and published over 30 original titles including *Surrealist Games, Mexico: The Day of the Dead* and *The Paradox Box*. He also edited *J.G. Posada: Messenger of Mortality* (1989) and *Alphabets and Other Signs* (1991). *The Redstone Diary*, edited with Mel Gooding, started in 1989 and is now published worldwide.

MEL GOODING is an art critic, writer and exhibition organiser. He has written many catalogue texts and contributed extensively to the art press and to magazines and newspapers. He is the author of several monographs on artists and architects and has curated many exhibitions. He is currently Senior Research Fellow at the Edinburgh College of Art.